Gothic Dreams

Dystopia

Fantasy Art, Fiction and the Movies

Publisher and Creative Director: Nick Wells
Senior Project Editor: Catherine Taylor
Picture Research and Editorial: Josie Mitchell
Art Director: Mike Spender
Copy Editor: Ramona Lamport
Proofreader: Dawn Laker

Special thanks to: Pat Mills for all his help sourcing fantastic imagery;
and Frances Bodiam.

FLAME TREE PUBLISHING
Crabtree Hall, Crabtree Lane
Fulham, London SW6 6TY
United Kingdom

www.flametreepublishing.com

First published 2015

15 17 19 18 16
1 3 5 7 9 10 8 6 4 2

A CIP record for this book is available from the British Library upon request.

ISBN 978-1-78361-321-2

Printed in China

Gothic Dreams

Dystopia

Fantasy Art, Fiction and the Movies

DAVE GOLDER

Foreword by Pat Mills

**FLAME TREE
PUBLISHING**

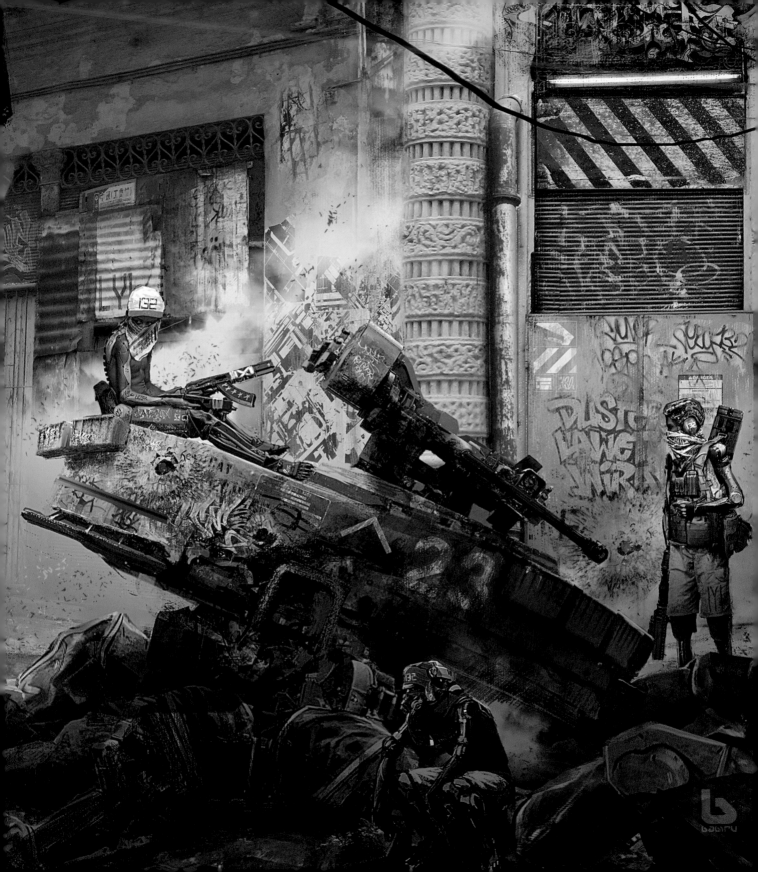

Contents

Foreword

Rule Dystopia! I'm so fond of dystopian worlds, I actually have a country named 'Dystopia' in my graphic novel series *Requiem Vampire Knight*. The Dystopians are a race of perfidious, Masonic, reptilian armsdealers. This is the first verse of their national anthem:

Rule Dystopia! Dystopia sells slaves!
Howitzers! Rockets! Guns and grenades!
We're civilising the world with terror and war,
Start crapping yourself when we knock on your door!

Who could they possibly be based upon?! That's surely some of the fun of dystopias: working out from where the creators get their ideas. When I commissioned artist Carlos Ezquerra to create Mega-City One in 'Judge Dredd', I was blown away by his soaring starscrapers which had a mysterious, dark beauty about them; a beauty that subsequent Dredd artists have largely replaced by grim, tower-block functionalism. It was only years later that I realized Carlos must have been inspired by Gaudí's fantastic, surreal architecture.

Architecture is a key ingredient in my other dystopian stories, whether it's the subterranean stalactite and stalagmite towers of Termight in **Nemesis** or the crane city of Mekana in **ABC Warriors** where people are transported from higher to lower levels by crane. The architecture also influences fashions, so the President of Mekana is the height of futuristic **GQ** fashion, wearing his valuable, antique, high-vis jacket inscribed with 'Return Trolleys'.

Some humour is essential if we're to enjoy worlds like **Children of Men**, **Blade Runner** and **The Hunger Games**. The reasons we like such dystopias are myriad, doubtless nourished by subconscious fears about the future, but surely they're healthier than the alternative: a squeaky clean, brilliantly lit, optimistic world with 1950s-style, grinning, clean-cut, exclusively white Caucasian families in super flying cars, enjoying techno-thrills and consumerist gadget gizmos. Now that is **truly** dystopian.

Pat Mills

www.millsverse.com

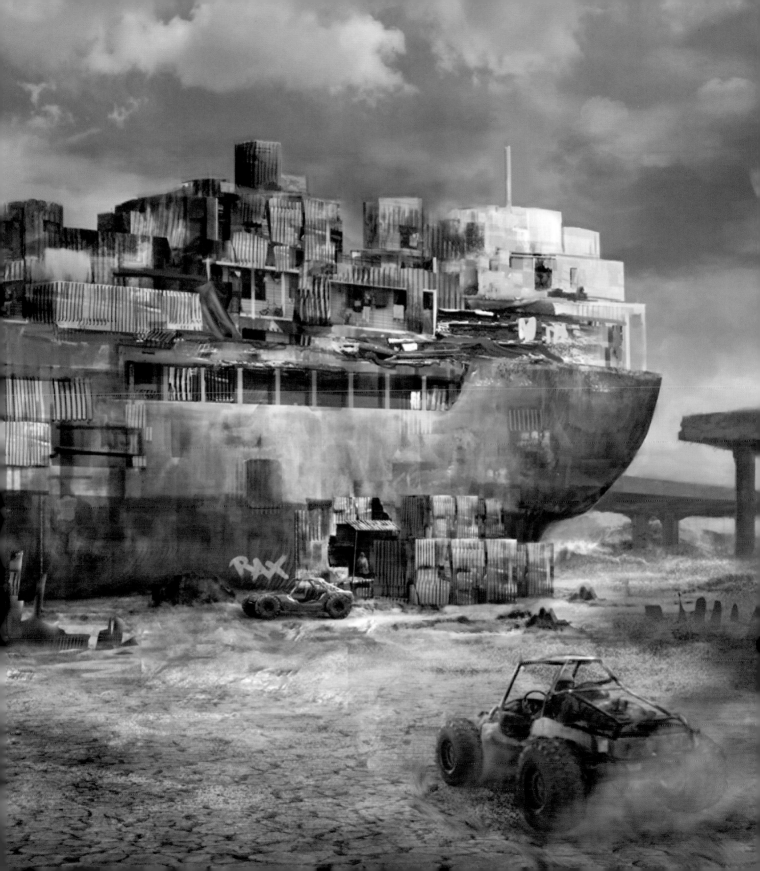

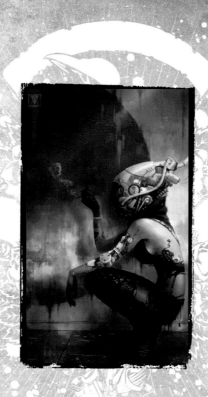

Apocalypse Wow

Dystopia – a nice place to visit, but you wouldn't want to live there. But why would anyone want to visit somewhere that George Orwell described as 'a boot stamping on a human face – for ever'? Dystopias, by their very definition (derived from the Greek for 'bad place'), are hardly a bundle of laughs.

Yet unrelenting bleakness hasn't harmed *The Hunger Games* (2012) at the box office. Cover-to-cover misery didn't stop *The Road* (2006) from winning a Pulitzer. Everybody loves 'The Walking Dead' (2010–), even though

half the cast seems to be eaten every week, including that one character you were rooting for. But maybe watching the terror is half the fun?

The Future's Not Bright

As anyone who ever watched 'Doctor Who' from behind a sofa knows, there is an exquisite thrill to be experienced from being scared – especially when the scares can be switched off – and dystopias offer disturbing intellectual scares as well as good old-fashioned 'made you jump' scares.

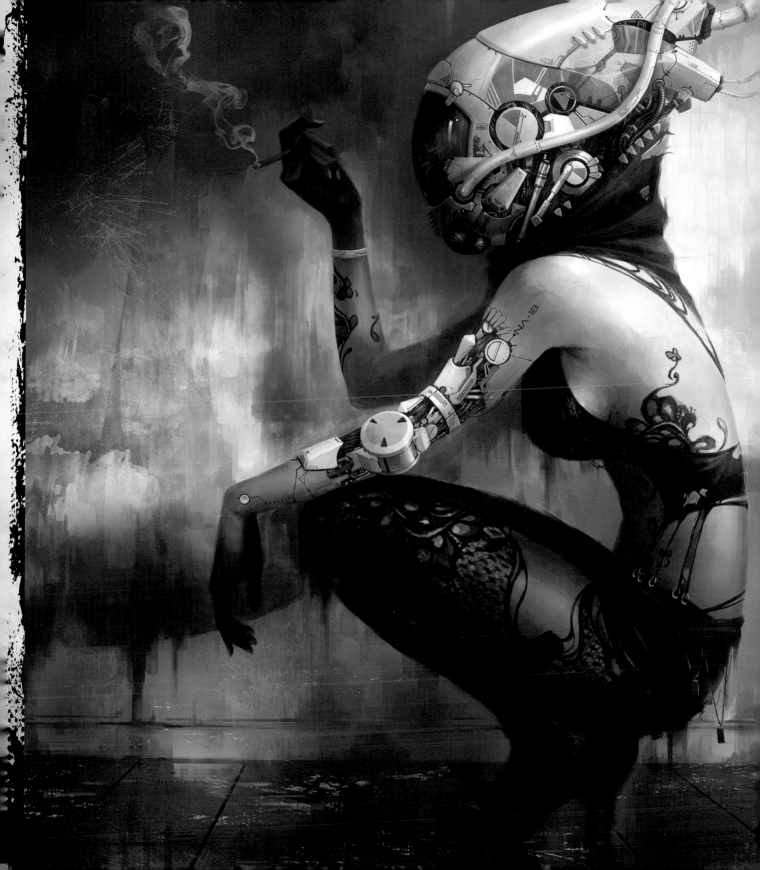

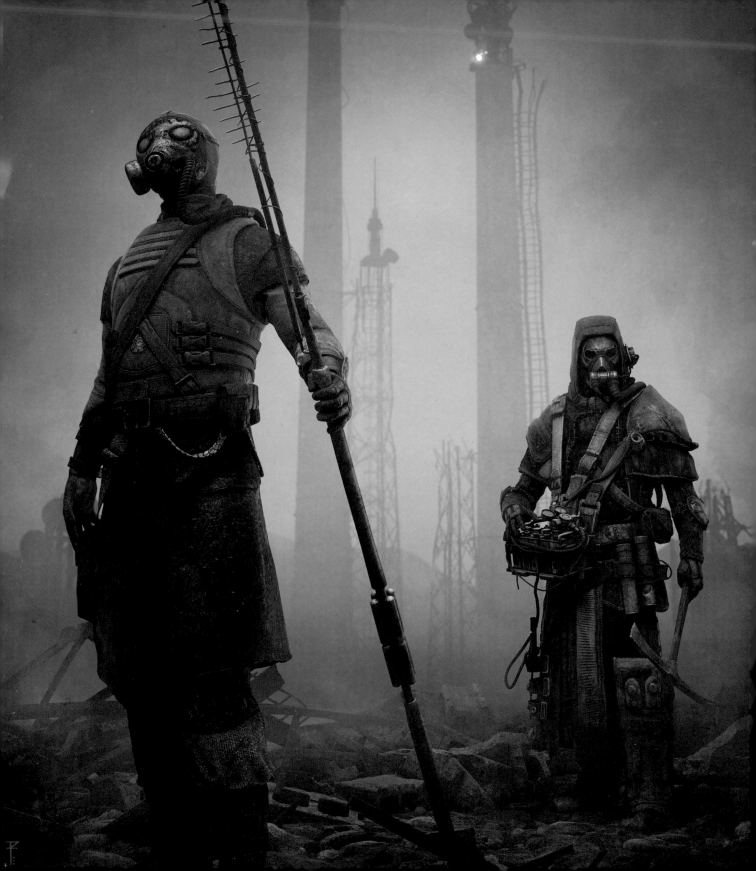

'The basic tool for the manipulation of reality is the manipulation of words. If you can control the meaning of words, you can control the people who must use the words.'

Philip K. Dick

They are the extreme sports of sci-fi. The white-knuckle rides. They take the genre to its limits and expose it in its purest form. They do not just present you with worlds in which some piece of technology has gone wrong; they show you entire worlds that have gone wrong. They aren't about Earth versus the aliens; they're about Earth after the aliens have won. They aren't about creating the matrix; they're about having to live with the consequences of it.

Circles Of Hell

Dystopias come in a rainbow of greys. The overcrowded city in **Blade Runner** (1982) is far from the empty wastelands of 'The Survivors' (1975–77 and 2008–10); the vampire apocalypse of **I Am Legend** (2007) is a very different future to the clinical, emotionless world of **THX 1138** (1971). There's the political dystopia, the post-apocalyptic dystopia, the eco-dystopia, the socio-economic dystopia and the whatever-the-hell-'Dominion' (2014–)-is dystopia.

So what defines a dystopia? What are the common themes? How has the genre developed and changed? And, perhaps most importantly of all, why are so many post-apocalyptic dystopias obsessed with beer- and wine-making?

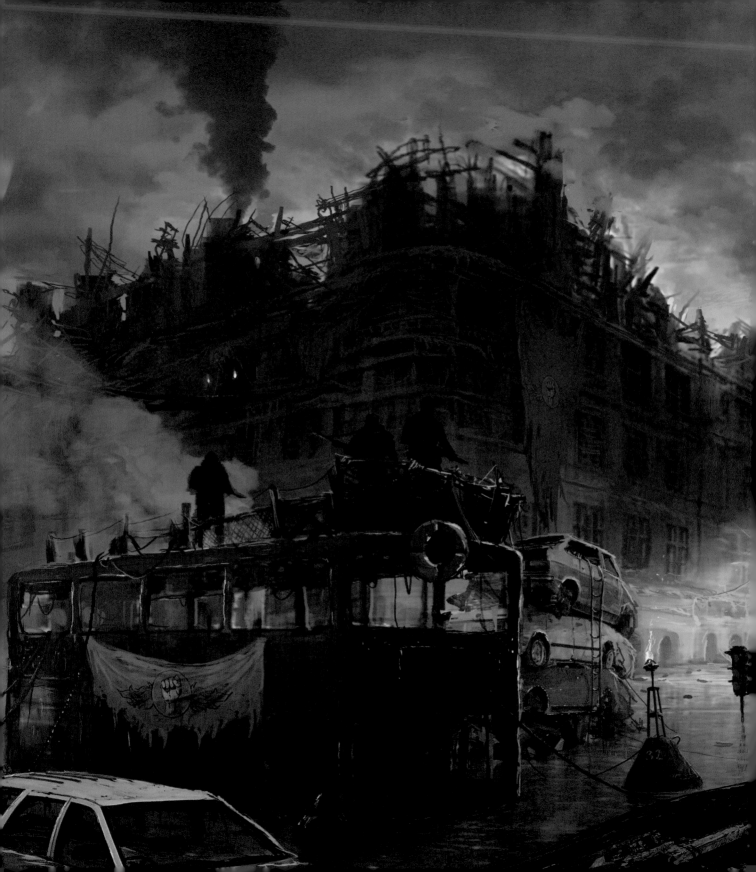

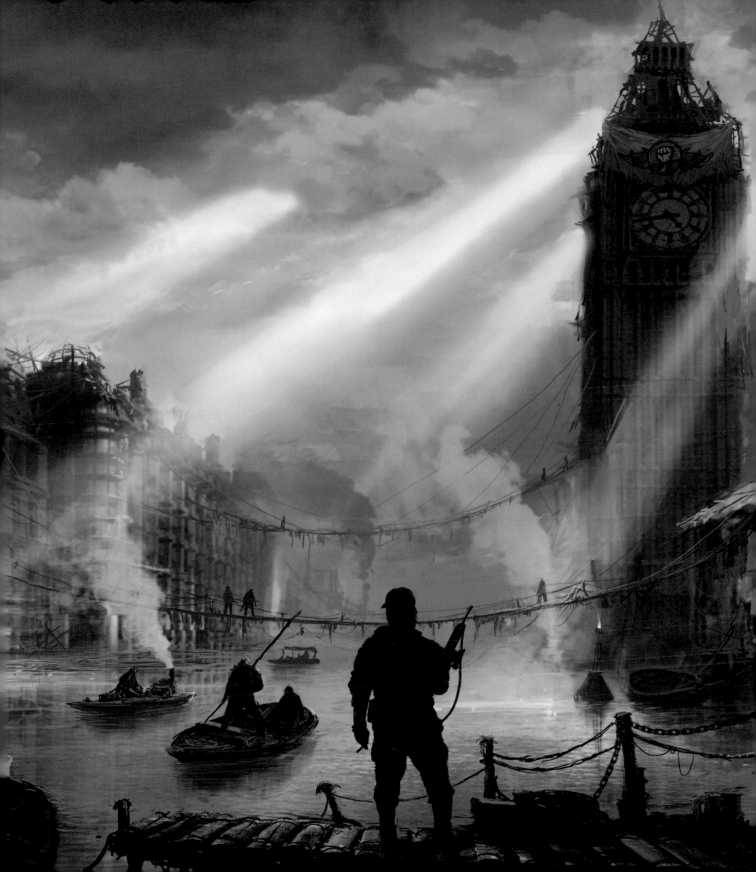

The Road To Dystopia

Dystopian fiction may be older than you think. The word itself wasn't coined until the nineteenth century by John Stuart Mills – as the opposite to the perfect Utopian society proposed by Thomas More in 1516 – but you could argue we've all been living in a dystopia ever since Eve sank her teeth into that apple. John Milton would appear to agree, if his epic 1667 poem *Paradise Lost* is anything to judge by.

It's not much of a stretch, either, to regard the Tower of Babel as a dystopian tale; a society that suddenly becomes dysfunctional. Its linguistic apocalypse, though, remains sadly unique to this day.

Breaking The Barriers

A dictionary definition of 'dystopia' is: 'an imagined place or state in which everything is unpleasant or bad, typically a totalitarian or environmentally degraded one.' In reality, the genre has so massively outgrown that dry description, to the point where there are so many subgenres and sub-subgenres of dystopia (post-apocalyptic, zombie-apocalyptic, vampire-apocalyptic),

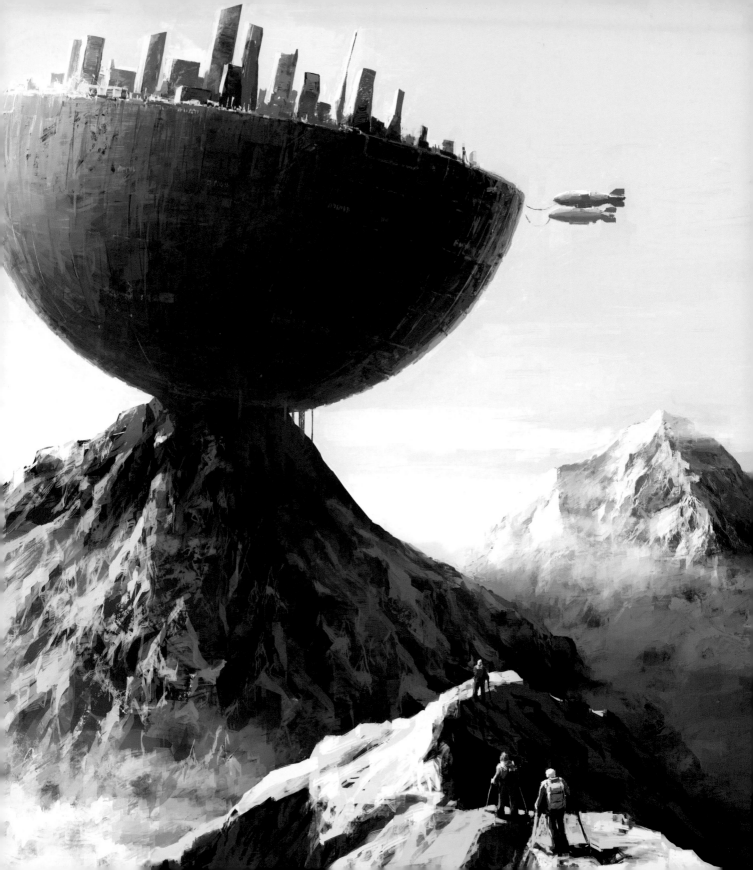

that you begin to wonder whether sci-fi is actually a subgenre of dystopia rather than the other way round.

After all, **Star Wars** may be light and frothy, but the heroes are rebelling against a totalitarian state.

That's just silly. Of course **Star Wars** isn't dystopian. Why not? Because it doesn't feel like it.

The Struggle

That's the thing about dystopias. They're defined less by a checklist of parameters and more by their mood, tone and characters. **Star Wars** might be dystopian if the hero were a downtrodden Death Star technician bringing the empire down from the inside, but it's not; it's about a prince with a birthright to become a powerful knight.

Dystopia has to be about the struggle. Heroes are forged, not born. Katniss Everdene is an ordinary girl forced into being a rebel. Rick Grimes must become a leader to fight zombies. They don't grasp fame and power; it's thrust upon them.

The Many Faces Of Dystopia

That's why there can be so many different types of dystopia; the setting is less important than the grim and gritty existence that the characters must endure. Mad Max surviving the nuke-blasted wasteland of Australia has more

'All revolutions are the sheerest fantasy until they happen; then they become historical inevitabilities.'

David Mitchell, 'Cloud Atlas'

in common with Winston Smith eking out an existence in Airstrip One than with the gun-toting Han Solo.

What all the settings do have in common is that something has fundamentally broken society. It may be environmental, supernatural, economic or religious, but something has gone desperately, seriously wrong. In dystopias, the enemy is not just bad guys being evil; it's the world itself that's your enemy.

A Different Breed Of Hero

Dystopias tend to breed antiheroes. They have to be tough to survive, and this often means they pay less attention to ethical niceties than the average Radio 4 listener. That means not just killing in self-defence; sometimes, it's killing to prove a point, or to maintain an appearance of strength, or as part of a strategic plan, or simply because they're pissed off.

The downside of living in a moral black hole is that you probably won't have a happy ending. It's not unheard of, but when it does happen (**28 Days Later**, 2002), it can feel incredibly artificial.

The Big Two

There are two main subcategories of dystopia. First, there's post-apocalyptic, in which the heroes wander around a ruined planet trying to survive. The apocalypse can come

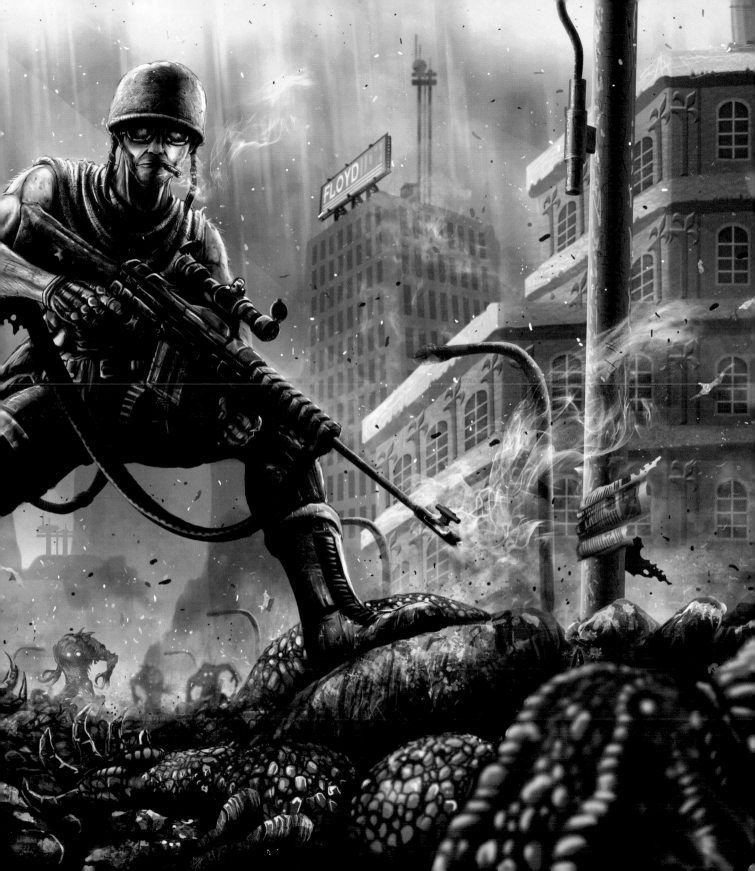

in many forms: nuclear (**The Postman**, 1997; 'Jericho', 2006–08); zombies ('The Walking Dead', and ninety-five per cent of all films with 'Of The Dead' in the title); vampires (**Daybreakers**, 2009; **I Am Legend**, 1954); and comets that blind you and leave you at the mercy of killer plants (**Day Of The Triffids**, 1951).

Second, there are the dark technological futures, where big business (**RoboCop**, 1987; **Snow Crash**, 1992), corrupt political systems (**Brazil**, 1985), ethically misused science (**Gattaca**, 1997) or some other bizarre social upheaval (angels in 'Dominion') has come to dominate the lives of ordinary people.

Warnings, Not Predictions

There is no limit to how dystopias could develop in the future. As new technologies emerge, there will be authors eager to warn of the dangers of using them unethically or unwisely. As new environmental threats are discovered, writers will want to explore how humanity might survive. It cannot be long, surely, until we have the first post-Coronal Mass Ejection apocalypse?

So be thankful that **Nineteen Eighty-Four** (1949) – for the moment – remains in the future, because writers wouldn't have the freedom to warn against such futures if it were not.

'*Abandon all hopes of utopia – there are people involved.*' Clayton Cramer

'*You don't know what it's like out there. You may think you do but you don't.*' Rick Grimes in 'The Walking Dead'

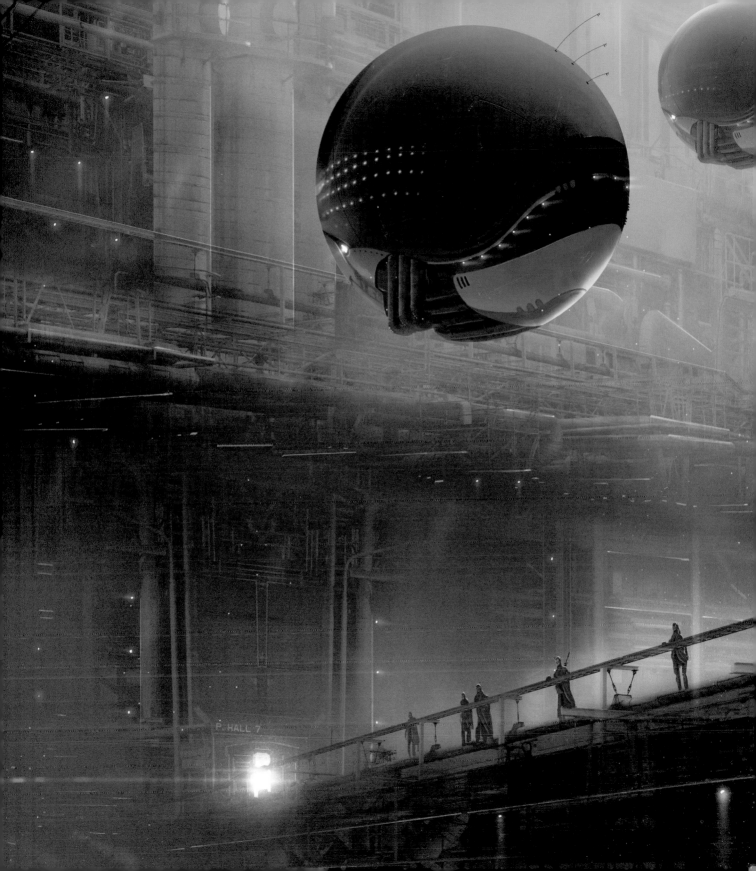

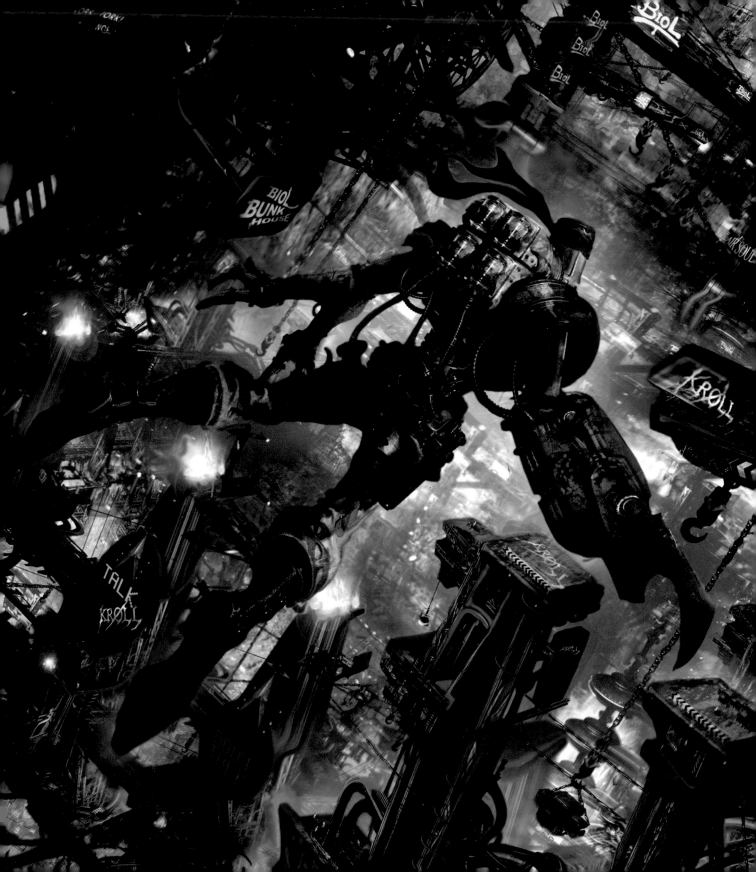

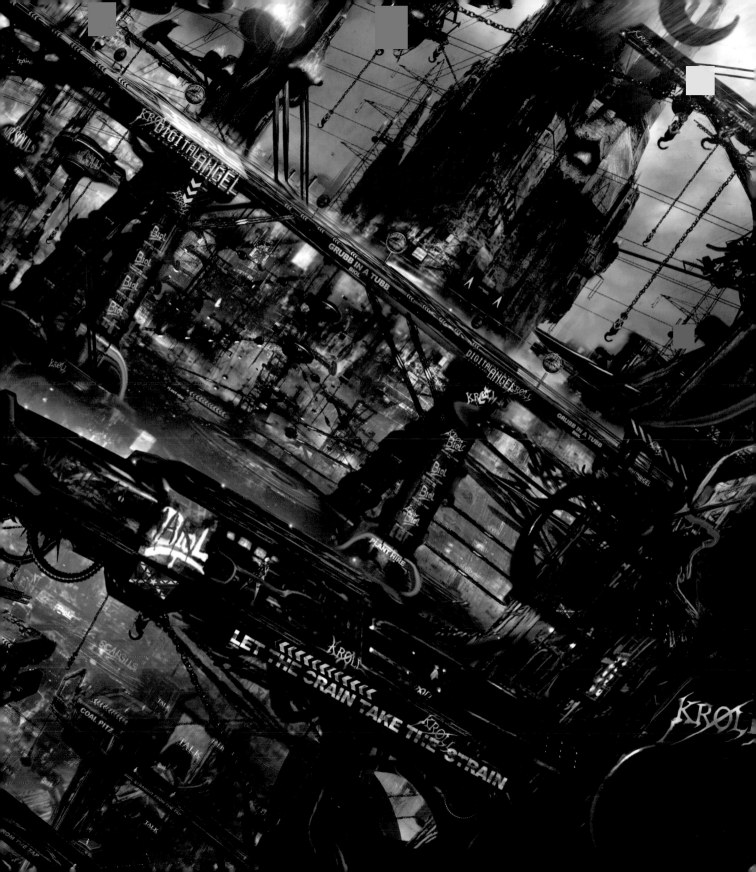

War Of The Words: The Literary Dystopia

It is uncannily apt that the *Oxford English Dictionary* attributes the first recorded use of the word 'dystopian' to a speech by John Stuart Mill in the House of Commons in 1868 ('They ought rather to be called dystopians'), because science fiction authors have been using dystopias to warn against the evils of corrupt governments ever since. Dystopias are rarely about the future, but are more usually an extreme extrapolation of the now.

Nineteen Eighty-Four will for ever be just around the corner. Concepts like Newspeak, thoughtcrimes and Room 101 may sound sci-fi, but none of them were actually beyond technological reach when George Orwell wrote the book, let alone now (though the telescreens might look sleeker these days).

Tomorrow Or Today?

Nineteen Eighty-Four isn't a date; it's a threat that's always looming, because it's concerned with how a corrupt ruling elite can rule through suppression of thought, and therefore knowledge too, rather than through scientific advances.

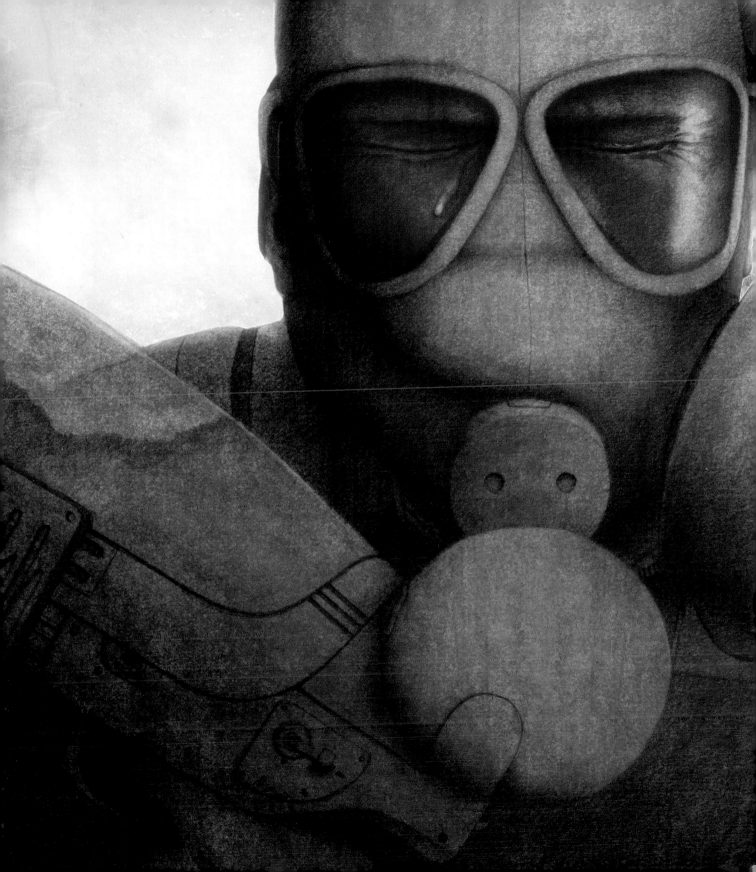

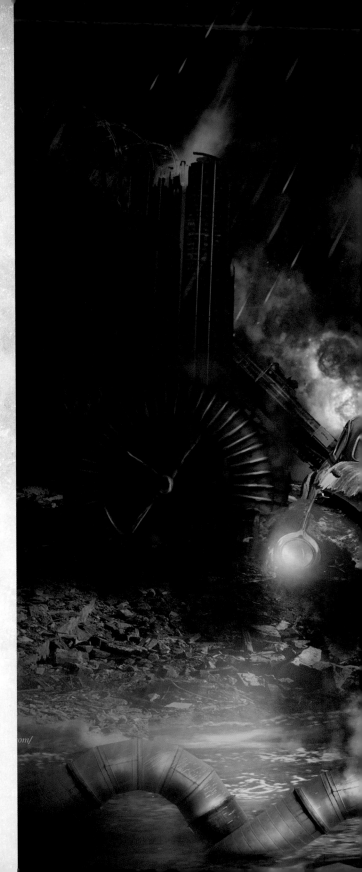

This is a common theme in dystopian fiction; where most mainstream science fiction is about technology gone wrong, dystopian fiction is about man going wrong. **The Handmaid's Tale** (1985) author, Margaret Atwood, goes so far as to claim that her work should not be termed science fiction because she does not write about 'things that have not been invented yet'.

The Big Two

That other monolithic dystopian milestone of the twentieth century, Aldous Huxley's **Brave New World** (1932), has more traditional 'sci-fi' trappings – human hatcheries and genetic engineering – but like Orwell's book, it is more interested in good old-fashioned mass brainwashing. Huxley's approach, though, is very different.

Orwell's world is one where the government ('Big Brother') rules by taking away your ability to think. It watches you. It controls you. It eliminates your individuality. It pares back language to such basics you do not even have the grammar to create an original thought. It's a living nightmare. Huxley's **Brave New World**, by contrast, is an apparently benign dystopia.

Hedonism Rules, OK?

Huxley explores recreational sex with no commitment and drugs on tap! The theory being: give 'em more of what they want and they won't notice their real freedoms are being

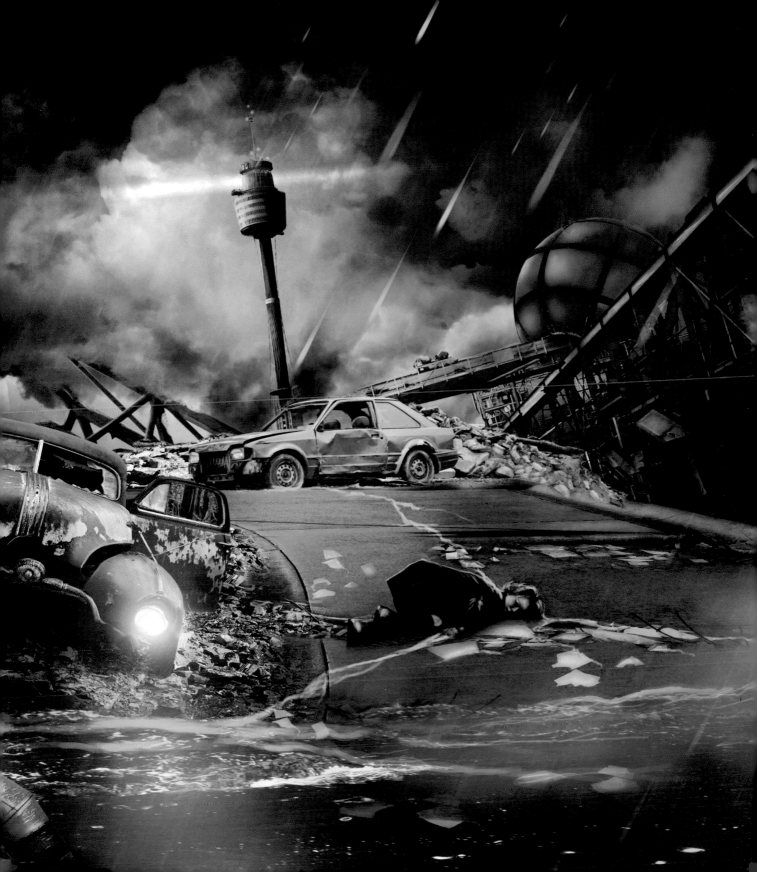

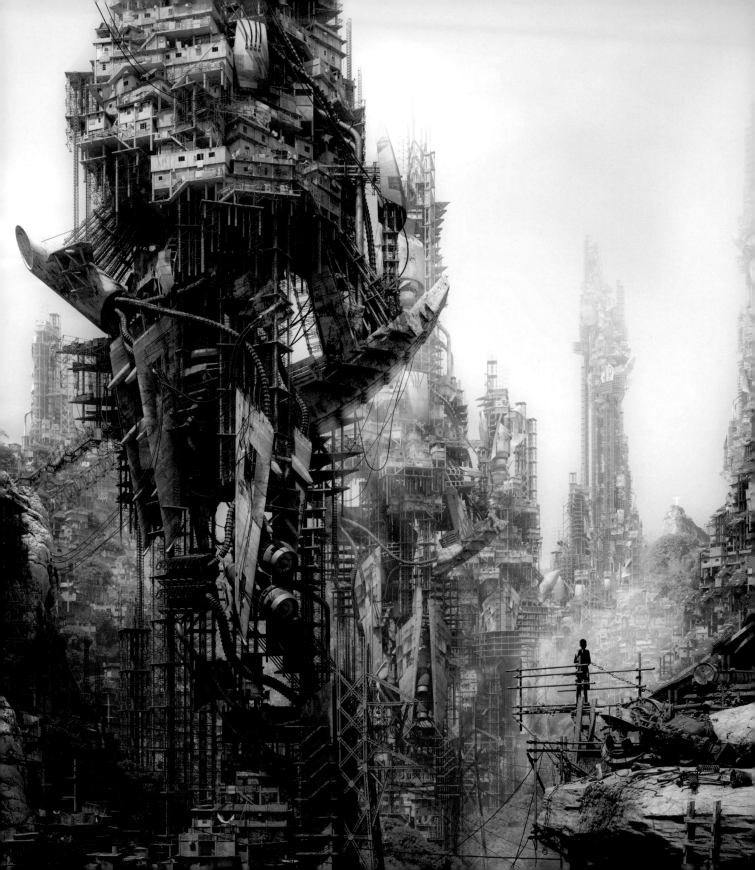

taken away. They won't care that their social status was dictated before they were born if you ply them with Soma. And if all else fails, breed them too stupid to notice.

Orwell's dystopia is one where thinking is a crime; Huxley's is one where thinking is simply too much effort.

Worlds Gone Bad

Before Orwell and Huxley, other authors were also offering these kinds of monolithic dystopian manifestos. H.G. Wells gave us **When The Sleeper Wakes** (1899) with his then-contemporary hero waking from a coma in 2100 to find that a corrupt government has invested his money in creating a totalitarian state.

Jack London's **Iron Heel** (1908) is a decades-spanning future history of an oligarchy formed from evil businessmen getting a stranglehold on America, an early forerunner of the kind of corporate dystopias seen in John Brunner's **The Sheep Look Up** (1972) and films like **RoboCop**.

People In Glass Houses

In **We** (1924), Yevgeny Zamyatin gives us the One State, a city nation constructed almost entirely of glass (so the authorities can keep an eye on you), where servile inhabitants with numbers instead of names march in unison. George Lucas's **THX 1138** could almost be the film adaptation.

'Telling a story in a futuristic world gives you this freedom to explore things that bother you in contemporary times.'

Suzanne Collins

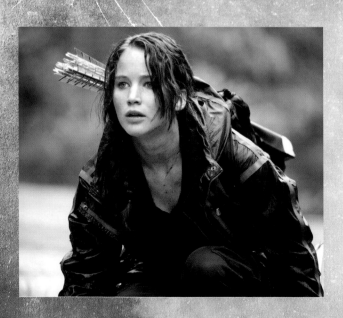

Ray Bradbury's **Fahrenheit 451** (1953), with its world where a fireman's job is to burn books, was one of the last examples from the Golden Age of science fiction. More recently that kind of dystopian world-building for its own sake has been a dying art. Instead, authors have tended towards exploring specific themes – genetics, cyberspace, slaughtering teenagers in the name of entertainment – set against dystopian backdrops.

Trend But Do Not Break

Technological advances and major shifts in social trends can give the genre a regular new lease of life every so often, with authors worrying about new ways in which the ruling elite can try to make our lives hell.

So John Brunner's **The Shockwave Rider** (1975) and William Gibson's **Neuromancer** (1984) both vie for the title of 'first cyberpunk novel' by combining dystopian backdrops with techno-fear about the potential invasiveness of the computer network. Our obsession with the body beautiful is given a dystopian spin in Scott Westerfeld's **Uglies** trilogy (2005), in which cosmetic surgery is forced on all 16-year-olds not deemed suitably beautiful.

Who's Watching Big Brother?

Then there are Stephen King's **The Running Man** (1982), Koushun Takami's **Battle Royale** (1999) and Suzanne Collins's **The Hunger Games** (2008), each of which satirizes modern TV culture's obsession with ever more

THE HUNGER GAMES:
CATCHING FIRE
EVERY REVOLUTION BEGINS WITH A SPARK

NOVEMBER 22
EXPERIENCE IT IN IMAX

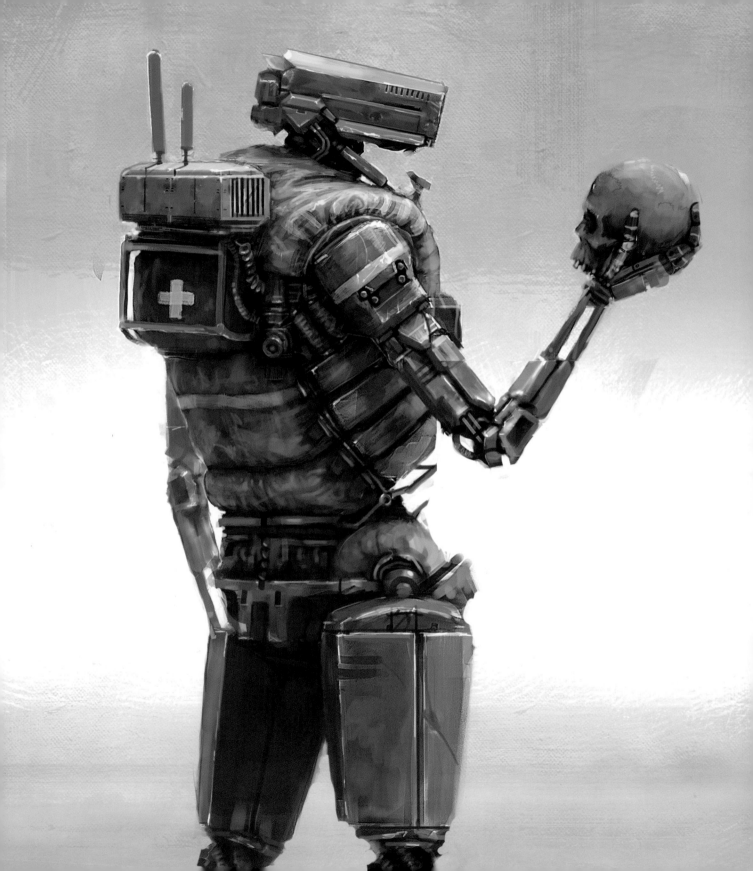

> *'In the original there was a man [with] a third eye in the top of his head…. On the whole the story seemed pleasanter without it.'*
> John Wyndham on 'The Chrysalids'

voyeuristic reality TV shows, by taking them to extremes. The audiences in all three books are literally baying for blood.

The growth of social networking inspired Ben Elton's **Blind Faith** (2007), in which everyone obsessively blogs their lives, and Gary Shteyngart's **Super Sad True Love Story** (2010), in which everyone pretends to be a teenager on their online feeds because youth is all important in this consumer-obsessed world.

Do You Want To Believe?

Religion invariably gets a bad rap, with most dystopias opting to repress it. But Robert Heinlein's **If This Goes On–** (1940) and Margaret Atwood's **The Handmaid's Tale** are concerned with autocratic religious regimes, the latter of which has a special place in hell reserved for women. In Ben Elton's **Blind Faith**, religious faith is made compulsory after science is blamed for the second flood.

Philip K. Dick's **Do Androids Dream Of Electric Sheep?** (1968) features a religion called Mercerism, which emphasizes humans' differences to androids.

The Bizarre Side Of Dystopia

Religion is repressed in P.D. James's **The Children Of Men** (1992), but finds a new expression when the childless leftovers of humanity start christening pets and giving dolls Christian burials.

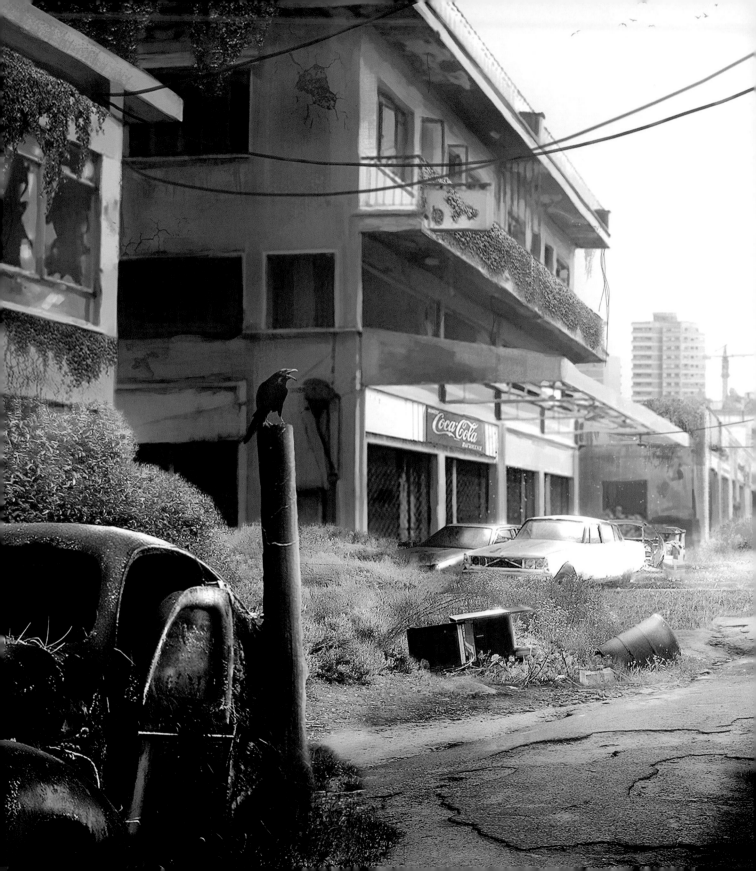

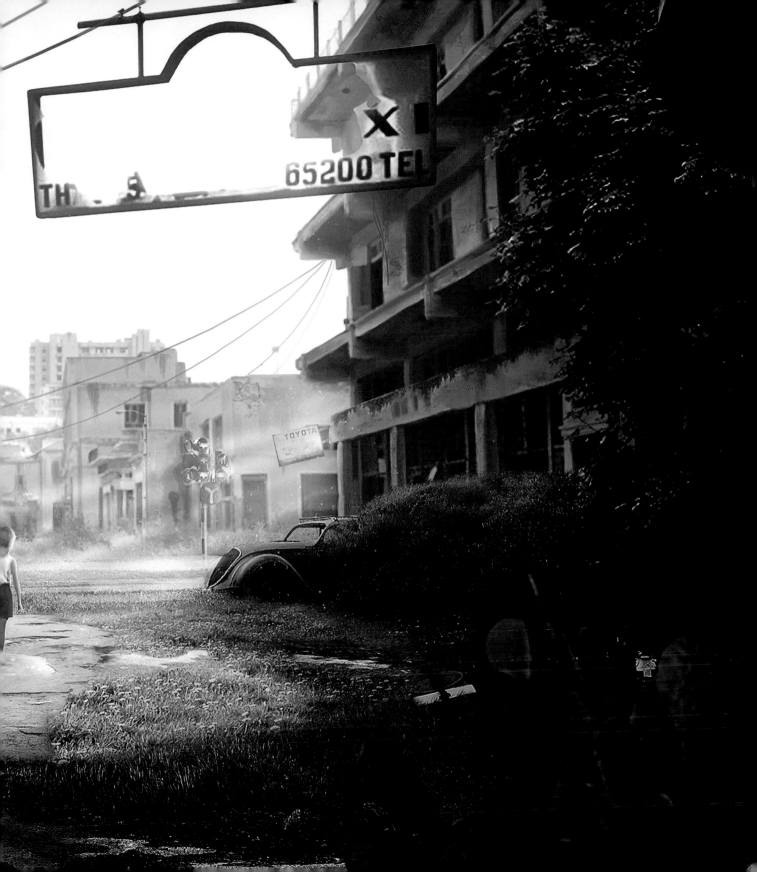

'There's no such thing as life without bloodshed…. Those who are afflicted with this notion are the first ones to give up their souls, their freedom.'

Cormac McCarthy

More whimsical approaches to religion can be found in **Brave New World**, in which Henry Ford has been elevated to Christ status and the tops of Christian crosses are broken off to represent the 'T' in Model T Ford. Walter M. Miller's **A Canticle For Leibowitz** (1959), a satirical post-apocalyptic tale, features the 'blessed blueprint', 'the sacred shopping list' and 'the holy shrine of Fallout shelter'.

I Am Not A Number

Dystopian cultures that strive to dehumanize their inhabitants by stripping them of individuality are also common. Names are replaced by numbers in Ayn Rand's **Anthem** (1938); love is deemed a disease and outlawed in Lauren Oliver's **Delirium** (2011); children are 'capped' by their alien overlords at the age of 14 to suppress creativity and rebellious thoughts in John Christopher's **The Tripods** trilogy (1967–69). In Veronica Roth's recent Young Adult (YA) series **Divergent** (2011), society sorts all 16-year-olds into 'factions' based on their skills and personality – the nightmare flip side of Harry Potter's Sorting Hat.

What's Your Handicap?

Egalitarianism is taken to its bizarre extremes in Kurt Vonnegut's short story 'Harrison Bergeron' (1961), in which innate advantages must be counteracted by handicaps; so the beautiful must wear masks and the athletic must wear weights, which at least would put an end to TV talent shows. Not all bad, then.

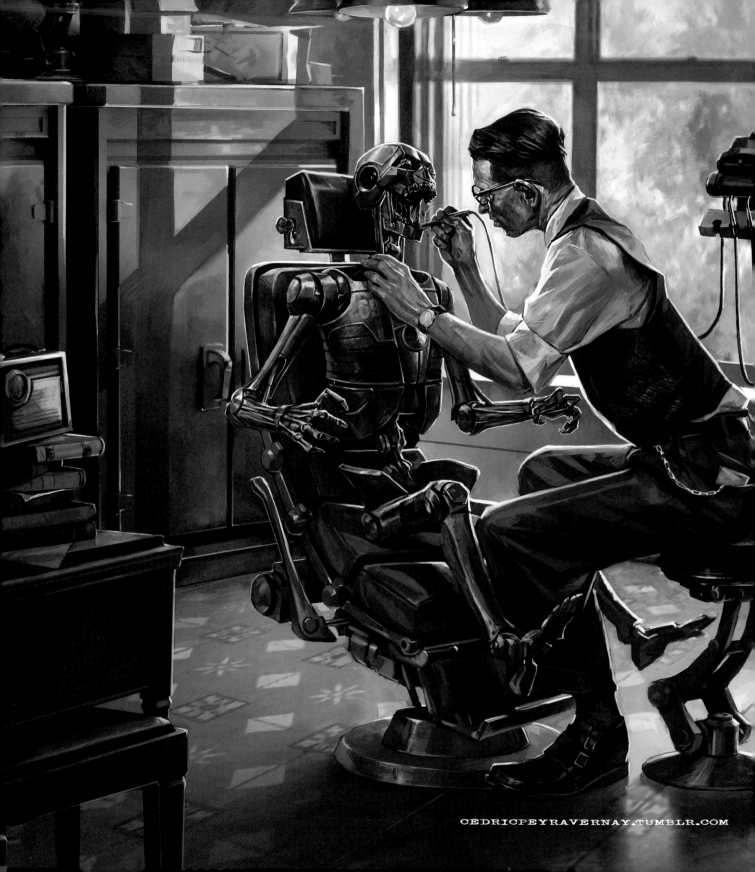

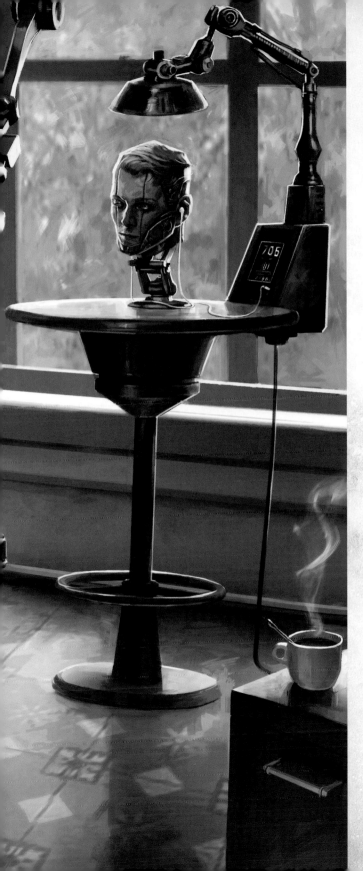

Totalitarian dystopias are also often short on fauna. Animals are so rare in **Do Androids Dream Of Electric Sheep?** that people create android pets, hence its hero, Rick Deckard, owns the 'electric sheep' of the title. In **Neuromancer**, horses are extinct and any meat is a delicacy, rare or otherwise.

It's In Your Genes (We Put It There)

While in real life H.G. Wells was a card-carrying supporter of eugenics ('It is in the sterilization of failure, and not in the selection of successes for breeding, that the possibility of an improvement of the human stock lies,' he wrote chillingly in 1904), most other sci-fi authors have warned against the horrors of genetics and selective breeding. In **Brave New World**, the lowest class, the Epsilons, are bred with reduced brain functions. Genetic engineering to create longer-living humans instead unleashes a virus that kills everyone by age 25 in Lauren DeStefano's **Wither** (2011), while in Margaret Atwood's **Oryx And Crake** (2003), gene engineering on-demand ultimately leads to monstrous freaks.

Tight Fit

Overpopulation has spurred many dystopian scribes into keyboard action. Unless you are very rich and/or privileged (some dystopias may have banned money in the name of egalitarianism, but they have never banned inherent inequality), real estate in New Totalitaria (or wherever) is rarely spacious. John Brunner's **Stand On Zanzibar** (1968),

> '*We're a government that believes in everybody having the illusion of free will.*'
> Anthony Burgess, 'The Wanting Seed'

Harry Harrison's **Make Room! Make Room!** (1966 – the basis for the 1973 film **Soylent Green**, but with the cannibalism twist) and Ally Condie's recent YA series **Matched** (2010) all take place in a world fit to burst with humans (though the world has now reached the nightmare world population figure – seven billion! – posited in the Harrison novel).

Oranges Are Not The Only Fruit

Anthony Burgess came up with a daringly controversial (for the time) solution to overpopulation in **The Wanting Seed** (1962), in which homosexuality is actively encouraged as a way of combating the problem. Burgess was, of course, the writer behind another dystopian classic, **A Clockwork Orange** (1962), which, aside from its legendary ultraviolence, also made use of another common dystopian trope – the new language. Orwell had Newspeak; Burgess gave us the Russian-influenced Nadsat, though the most memorable examples tend to be the non-Russian ones: 'apply polly loggy' for sorry, 'cancer' for cigarette and 'in-out in-out' for sex.

Somebody Think Of The Children!

The Children Of Men is the most famous example of the polar opposite of a population problem. P.D. James writes about a future where women stop giving birth, and the resulting breakdown of society allows a despot, Xan Lypiatt, to abolish democracy, decree himself 'The Warden' and create a dictatorship by any other name.

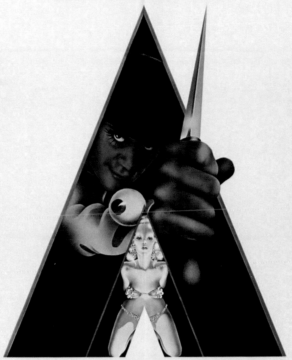

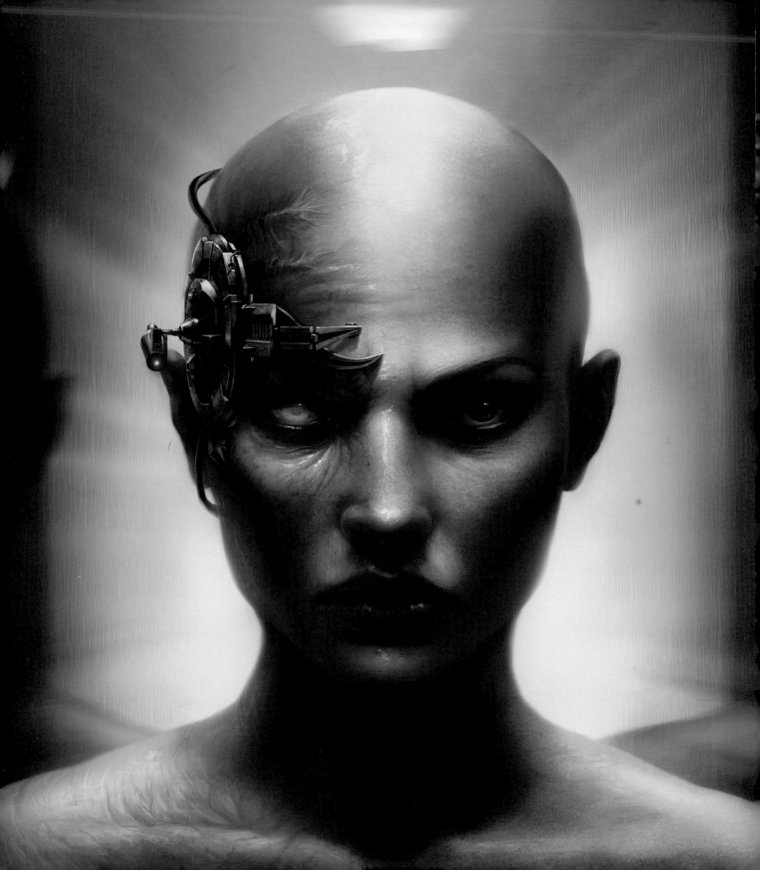

Similarly, in Margaret Atwood's **The Handmaid's Tale**, birth rates are in serious decline because of sterility problems and sexual diseases. In this case, the ruthless ruling classes employ fertile 'handmaids' – usually less than willingly – to pop the sprogs for them.

Whoops Apocalypse

Post-apocalyptic dystopias haven't been quite so popular in fiction as they have onscreen, but 'after-the-fall' literature has nevertheless had its notable landmarks. H.G. Wells was first off the block with **The Time Machine** (1895), ostensibly a time-travel novel, but which also showed us life after a nuclear war (a theme he revisited in **The Shape Of Things To Come** in 1933), and then, in the far, far future, a two-tiered future where the 'leisured classes' have become the spineless, leisure-loving Eloi, and the working classes have become light-fearing troglodytes called Morlocks. It's *The Daily Mail's* worst nightmare.

Heavy Plants Crossing

By the mid-twentieth century, Britain's king of stiff-upper-lipped sci-fi, John Wyndham, was genre-splicing with dystopias. **The Day Of The Triffids** is part 'monster movie', with killer walking plants taking advantage of the fact that nearly everyone on Earth has been blinded, while **The Chrysalids** (1955) – which would have been called a Young Adult novel if the term had been around back then – is the first in a whole new subgenre that's currently riding high: super-powered mutant teens struggling to find

'I don't think science fiction books are good predictors of the future. What they're really good at is reflecting the present.'
Cory Doctorow

> '*Mankind which began in a cave and behind a windbreak will end in the disease-soaked ruins of a slum.*'
> H.G. Wells,
> 'The Fate Of Man'

acceptance in a dark future society. Wyndham manages to make the simple image of a six-fingered hand feel like an icon for the freedom to be different.

Out Of The Frying Pan

J.G. Ballard made a name for himself with a series of 'catastrophe' novels – including **The Drowned World** (1962), **The Burning World** (1964) and **The Crystal World** (1966) – which at first glance may seem to be the literary equivalent of disaster movies ('The oceans are rising!', 'There's a global drought!', 'A jungle is crystalizing everything it touches!'), but Ballard's work adds an impressionistic dimension, the worlds he creates being the outward embodiments of his characters' unconscious minds. It is genuinely thought-provoking stuff, and Ballard went on to write such modern classics as **Crash** (1973) and **High Rise** (1975), that skirted on the edges of dystopia.

Road Rage

In Harlan Ellison's **A Boy And His Dog** (1969), the eponymous buddies forage for food on the surface of a ruined America while most of the population cowers in subterranean cities.

In 2006, Cormac McCarthy gave us **The Road**, which, on a conceptual level, adds little to the genre: a father and son fight to survive in a particularly dusty (but never explained) post-apocalypse world where people are really horrible to

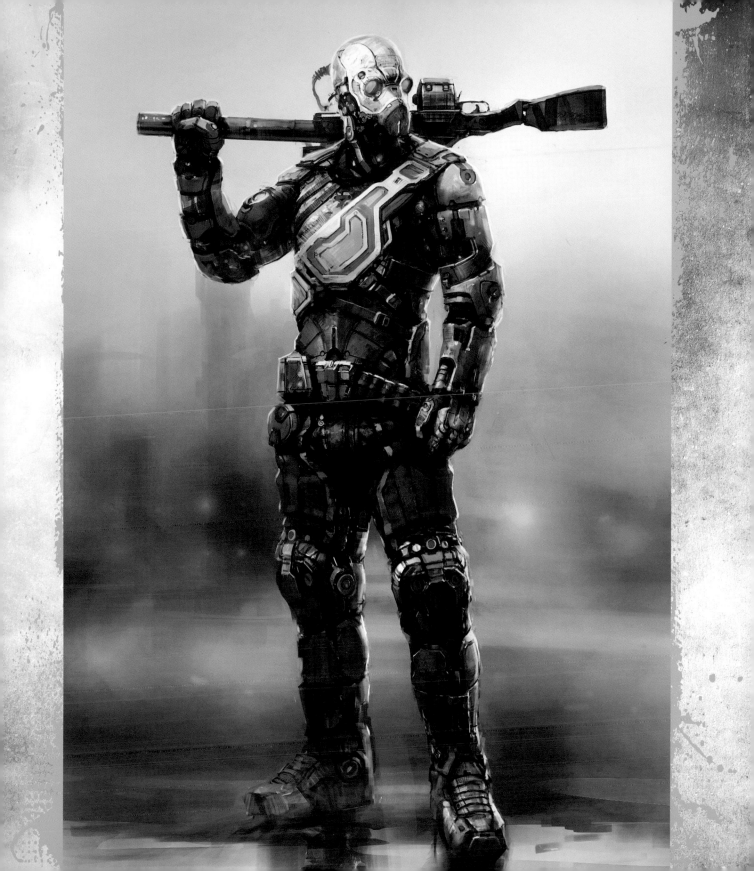

each other. But McCarthy uses all the tropes to throw the spotlight on a harrowing yet beautiful central relationship. It may be the grimmest book ever written, but it shows the power of love and hope.

Out For Blood

In a reversal of the usual trend, zombie-geddon and vampire-apocalypse tales largely became popular in films before they made a literary splash, though there was one notable exception: Richard Matheson's *I Am Legend*, in which the last surviving human ekes an existence in a world overrun by vampire-like creatures. In a clever twist (**spoiler alert**), he dies realizing he has now become a legendary figure to this new race.

It took Max Brooks to put the genre back on the literary map, with *The Zombie Survival Guide* (2003) and *World War Z: An Oral History Of The Zombie War* (2006).

Braaaaaaiiiiiinnnnnzzzzzz!

While *The Zombie Survival Guide* is tongue-in-cheek, *World War Z: An Oral History Of The Zombie War* is anything but. Not so much a novel, it's a series of personal accounts from various sources from throughout the zombie outbreak. The film version is based on just one of those accounts, and very loosely at that.

Film director Guillermo del Toro chipped in with *The Strain* trilogy (2009), written with Chuck Hogan, in which

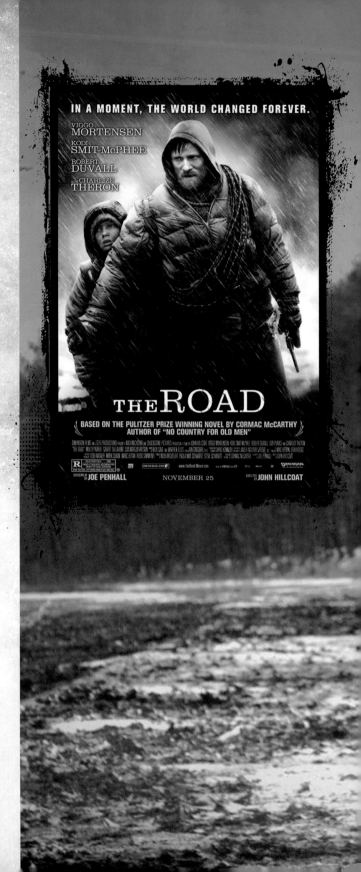

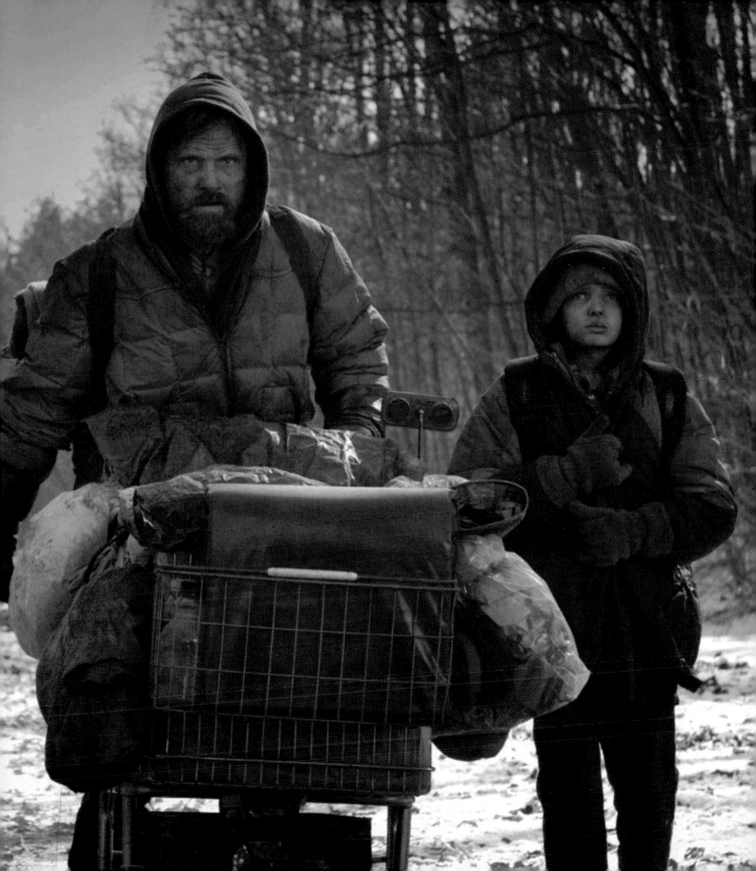

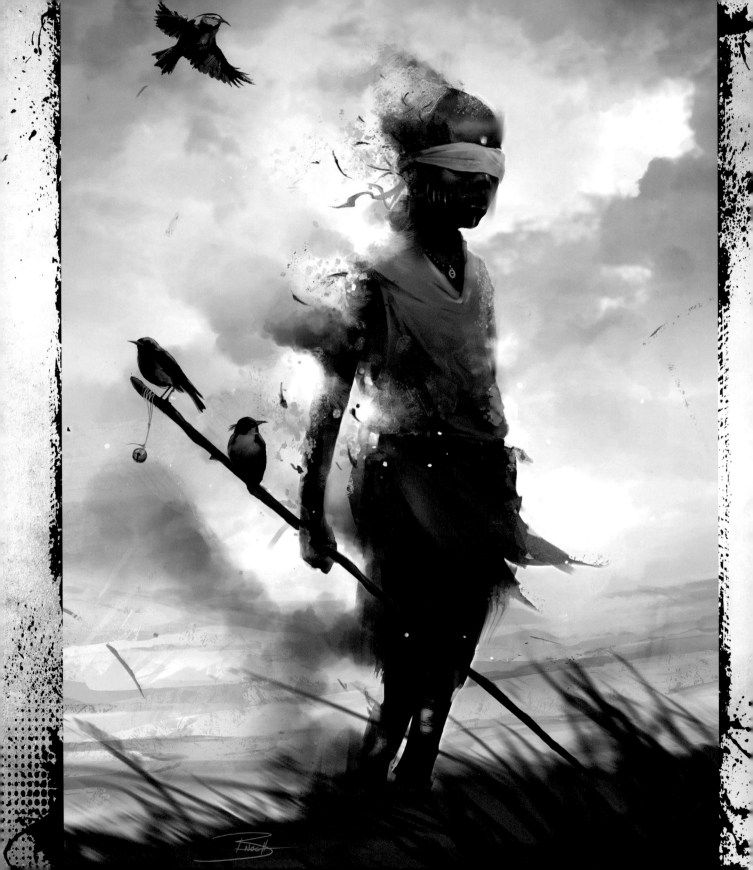

'Most mutations would naturally be pretty unpleasant, but that would swamp the whole story. So one minimizes the most unpleasant ones.'
John Wyndham on 'The Chrysalids'

a new breed of vampires with enormous blood-sucking tongues takes over the world. More viral vampires cause problems for the human survivors of the post-apocalypse world in Justin Cronin's **The Passage** (2010). The genre now appears to be in fine fettle on the page as well as on screen.

Teens Take Over

The current breeding ground for dystopias, though, is the Young Adult novel. The success of **The Hunger Games** has seemingly spawned an entire cottage industry, with authors desperate to find new twists on plucky teens fighting for freedom from authoritarian grown-ups. But teen dystopias in fiction are really not a new phenomenon at all.

As mentioned earlier, John Wyndham's **The Chrysalids** is a YA novel by any other name, while Peter Dickinson's **The Weathermonger** (1968) is a fantasy about a boy who can control the weather, set in a medieval world where all technology has broken down.

Shadow Of The Bomb

Robert O'Brien's **Z For Zachariah** (1974) is a wonderfully tense story about a girl left alone on a farm that, thanks to a freak mini-climate in the valley where it's situated, survives nuclear Armageddon. Unbelieveably, she survives alone for a year, but when a man in a hazmat suit stumbles into the valley, is he friend or foe?

> *'If you want a vision of the future, imagine a boot stamping on a human face – for ever.'*
>
> George Orwell, *'Nineteen Eighty-Four'*

Then, in 1983, prolific children's author Robert Westall gave us **Futuretrack Five**, set in a meritocracy where successful children join the 'Establishment' and failures are banished beyond 'the Wire'. It's virtually a blueprint for every YA dystopian novel of the twenty-first century. And boy, have there been a few.

The Young Adult Revolution

So, we have a future where your partner for life is chosen for you by the state in Ally Condie's **Matched** (2010) / **Crossed** (2011) / **Reach** (2012) trilogy. A corrupt council on a space station containing the last remnants of humanity sends teenage criminals to a post-apocalyptic Earth to see if it is habitable again in Kass Morgan's **The 100** (2013), which is again part of a series with the second book **Day 21** (2014) recently published. Marie Lu's **Legend** (2011) is set after 'The Plague', while Tahereh Mafi's **Shatter Me** (2011) is set in the wonderfully named 'The Reestablishment'. 'The Federal Bureau of Reformation' rewrites the American Bill of Rights in The Moral Statutes in Kristen Simmons's **Article 5** (2012).

We Haven't Finished Yet...

In Lauren Oliver's **Delirium** (2011) / **Pandemonium** (2012) series, the government wants you to believe love is a disease known as 'amor deliria nervosa'. A cure for the disease has been developed and is mandatory for everyone at the age of 18.

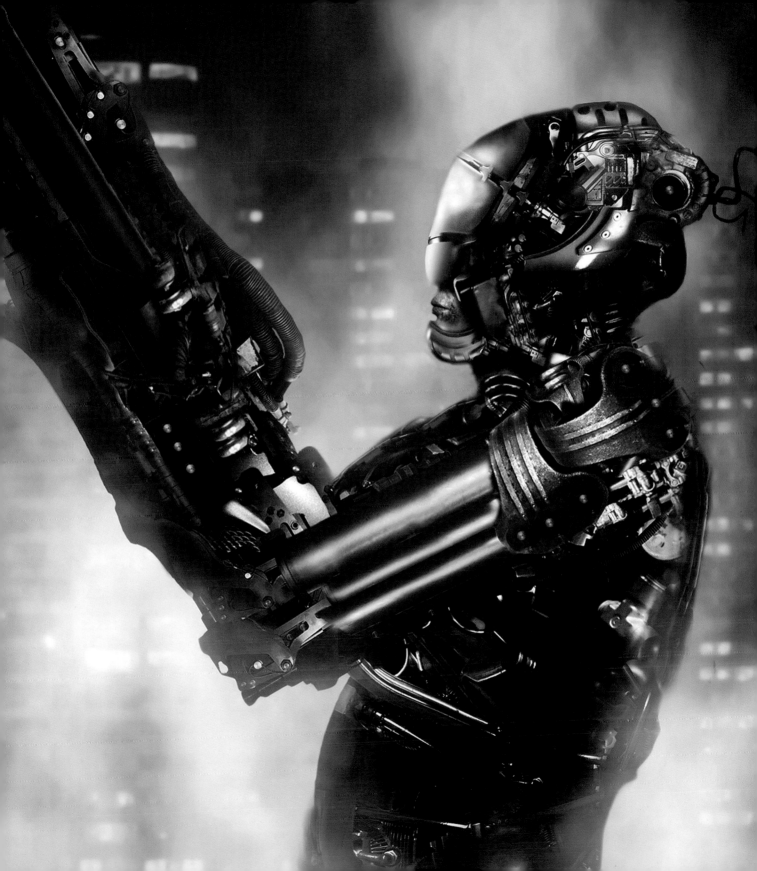

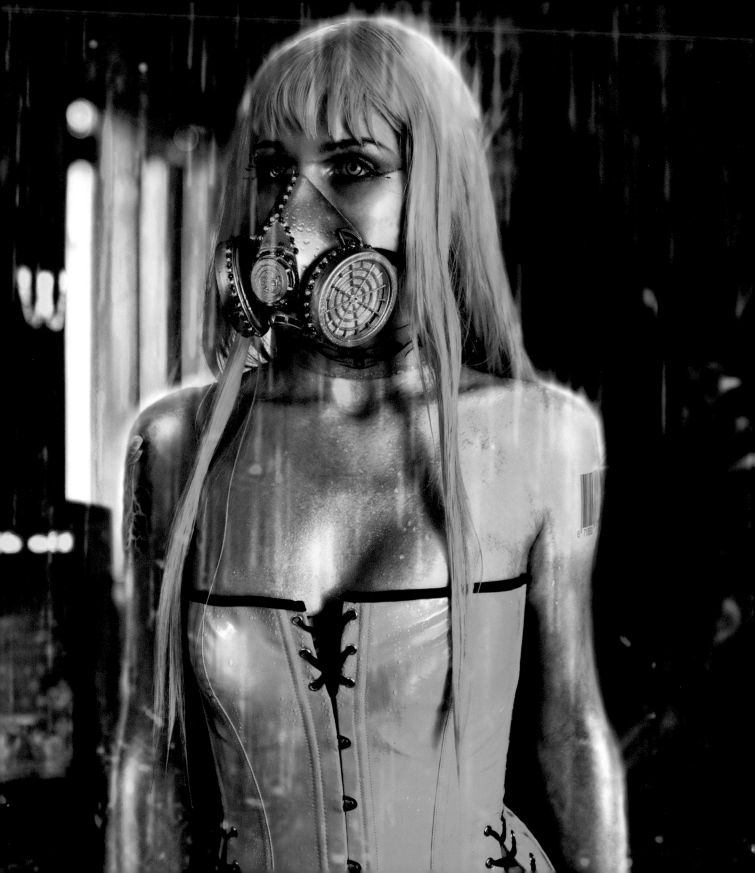

J. Gabriel Gates, meanwhile, locates his teen hostage drama **Blood Zero Sky** (2012) in a world that has been privatized by N-Corp, aka 'the Company', people are judged on their financial credit scores, and work output and those deemed 'unprofitable' are sent to work camps.

This is a trend that may well only run out of steam when the writers run out of new, cool-sounding names to call their apocalyptic events.

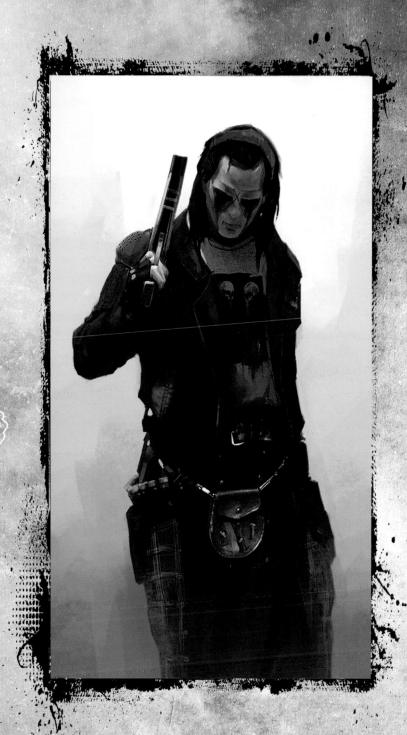

'I am a preventer of futures, not a predictor of them. I wrote Fahrenheit 451 to prevent book-burnings, not to induce that future into happening, or even to say that it was inevitable.'
Ray Bradbury

Who's Watching Whom?

When it comes to TV and films, there's a dystopia to suit every budget. *I Am Legend* lavished millions of dollars on computer-generated zombie armies, whereas *Mad Max* (1979) made do with the Australian outback, a skeleton crew, a few cars and some fake blood.

Similarly, on TV you have the FX-packed Steven Spielberg-produced alien invasion series 'Falling Skies' (2011–) at one end of the spectrum, while at the other end is the BBC's 'Survivors' (1975–77) in which most of the characters spent their post-viral apocalypse trudging around woods and fields worrying about their crops not growing.

Feeding The Hunger

The success of **The Hunger Games** (2012) has clearly refreshed an appetite for onscreen dystopias, especially on US TV. Recent shows include the J.J. Abrams-produced 'Revolution' (2012–14) – set in a world suffering a permanent electricity blackout – and the teen-targeted 'The 100' (2014), a post-apocalyptic **Lord Of The Flies** with more hair gel.

And it can be no coincidence that the popular YA book trilogy **Divergent** (2011–13), one of the slew of teen dystopian novels

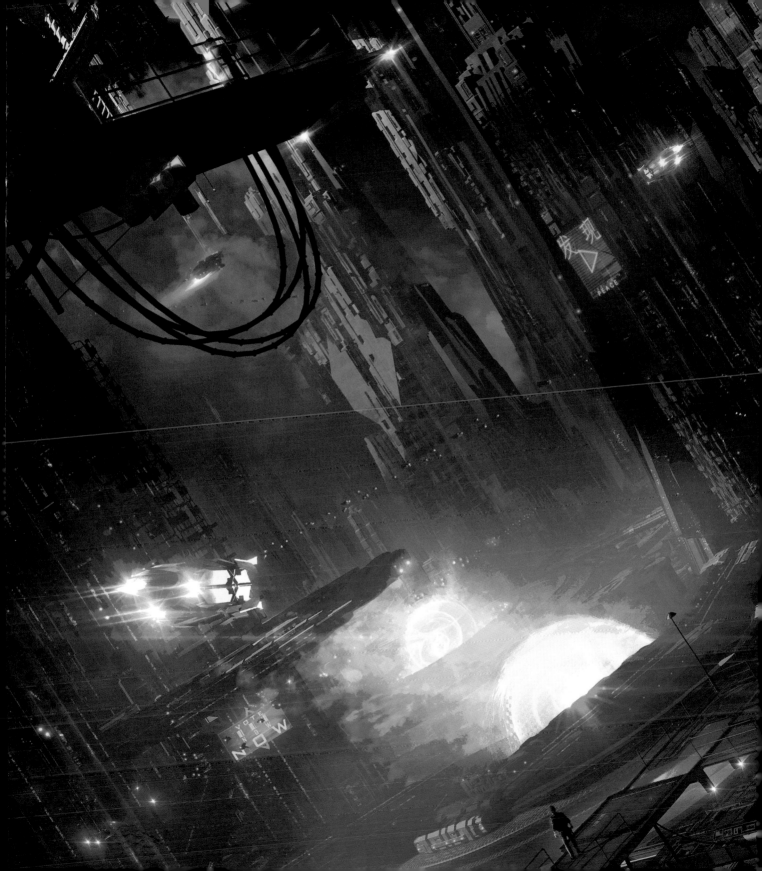

> '*They asked me to do a couple of episodes of "The Walking Dead" but I didn't want to be a part of it. Basically it's just a soap opera with a zombie occasionally.*'
>
> George A. Romero

published in the wake of **The Hunger Games** (2008), is currently being unleashed on the big screen in four parts (2014–17) – the final book, **Allegiant**, being split into two movies, as is the current fashion.

Nothing New

But it's hardly a new phenomenon. **The Hunger Games** has certainly made the genre trendy again, but ever since the 1960s saw the first great surge in screen dystopias – with French new-wave directors Chris Marker, Jean-Luc Goddard and François Truffaut giving us **La Jetée** (1962), **Alphaville** (1965) and **Fahrenheit 451** (1966), respectively – cinema and TV has provided a steady stream of popular nightmarish visions of the future.

Prior to that, dystopia's screen career was sporadic: H.G. Wells's history of the future, **Things To Come** (1936); a terrible version of **1984** (1956); the nuclear drama **On The Beach** (1959). But the very first screen dystopia was one of the most influential science fiction films ever made.

How Do We Solve A Problem Like Maria?

German director Fritz Lang's expressionist, black and white, silent epic **Metropolis** (1927) had all the hallmarks of an Orwellian future two decades before **Nineteen Eighty-Four** was even written. Workers in drab overalls march in unison in mind-numbing jobs, mere cogs in the massive machines deep in the bowels of an overcrowded city. Rich bureaucrats

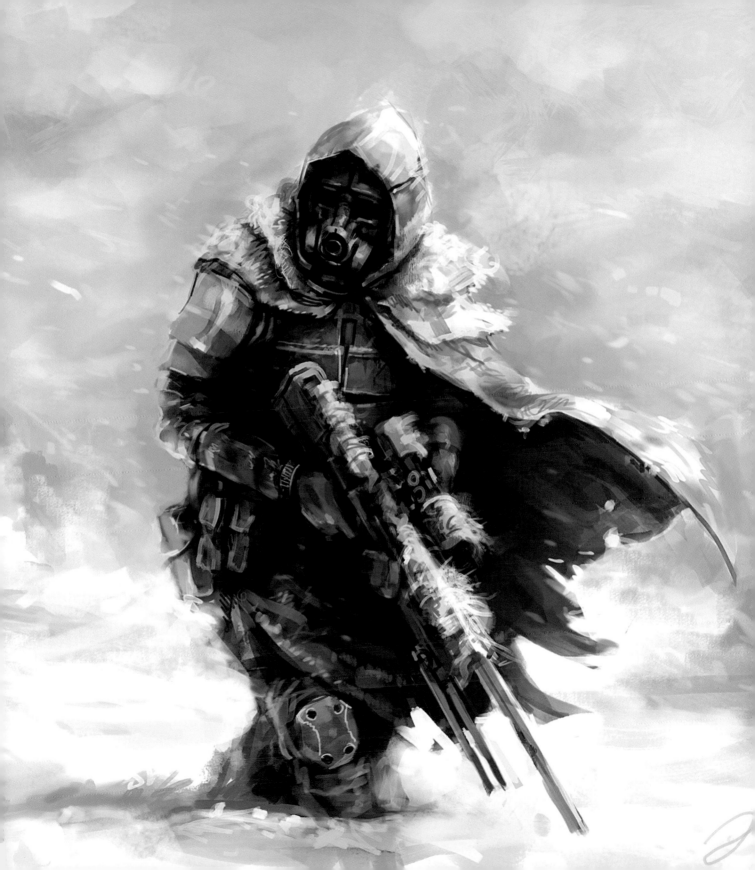

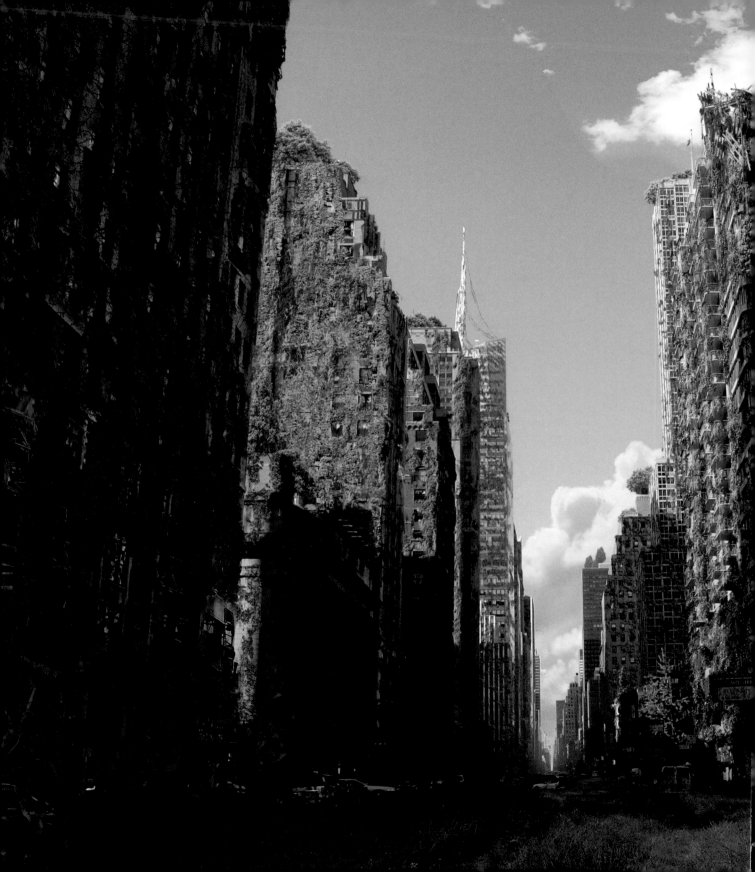

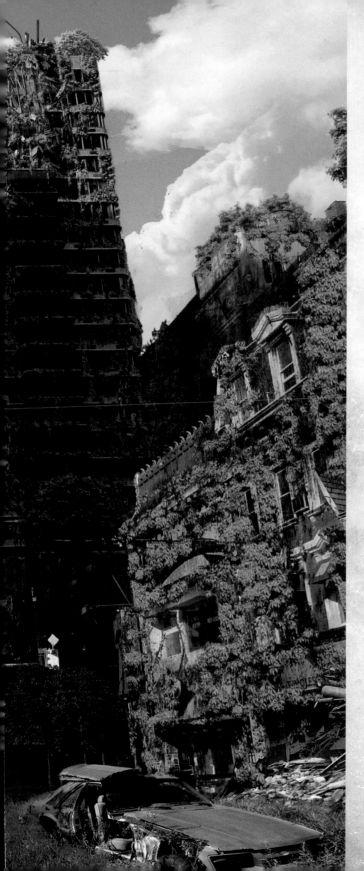

live high above in luxury penthouses. The man in charge, Jon Frederson, is more business tycoon than politician as he causes chaos with the guidance of Rotwang, a scientist.

There is a workers' revolution, though, bizarrely, it is instigated by Frederson himself when he sends a robotic agent provocateur – the now-legendary 'false Maria' – to stir up trouble.

Hot In The City

Muddled though its politics may be, **Metropolis** remains a masterpiece, a film truly ahead of its time in so many ways. George Lucas has admitted that the false Maria was an inspiration for the look of C-3PO in **Star Wars** (1977), and virtually every sci-fi city ever committed to film since owes a debt to the criss-crossing gantries and monolithic skyscrapers of Lang's film.

Certainly, the city models in **Things To Come** owe **Metropolis** a huge debt, but Wells's sprawling history of the future from 1940 to 1936 – with post-nuclear apocalypse segments – is too episodic, unfocused and preachy to have the same kind of impact as Lang's film.

The 1970s Explosion

While the 1960s was the decade of cool, detached French new-wave dystopia, Hollywood reclaimed the genre in the 1970s in a big way, and with incredible diversity.

> '*In 2077, you trust the tech. You don't trust anything else because the tech will do it all for you.*'
> Rachel Nichols on 'Continuum'

George Lucas gave us a fairly traditional totalitarian future in **THX 1138**, in which the emotionally stunted, bald-headed, numbered citizens of a consumer-obsessed future are suppressed by robot police. **Silent Running** (1972) was not dystopian per se, but it was set on a ship containing the world's last forest, implying that life on Earth must be pretty miserable; does everyone have to carry their own oxygen supply?

Creative Ways To Die

The world of **Logan's Run** (1976) at first seems like a hedonistic utopia, especially for men (the women in the film tend to come across as willing sex slaves, which has more to do with the weaknesses of male scriptwriters than a comment on sexual inequality). But that's not taking into account the fact that everybody is sent to 'the carousel' to die at the age of 30 (in the original novel, it's 21).

Deathrace 2000 (1975) and **Rollerball** (1975) were both extreme blood sports created by corrupt, immoral societies, while in **Soylent Green**, overpopulation is solved by cannibalism (worst advertising slogan ever must be 'Soylent Green is YOU!').

The Orange Revolution

The milestone dystopian movie of the 1970s, however, was British. Stanley Kubrick's adaptation of **A Clockwork Orange** (1971) delivered such a highly stylized future of

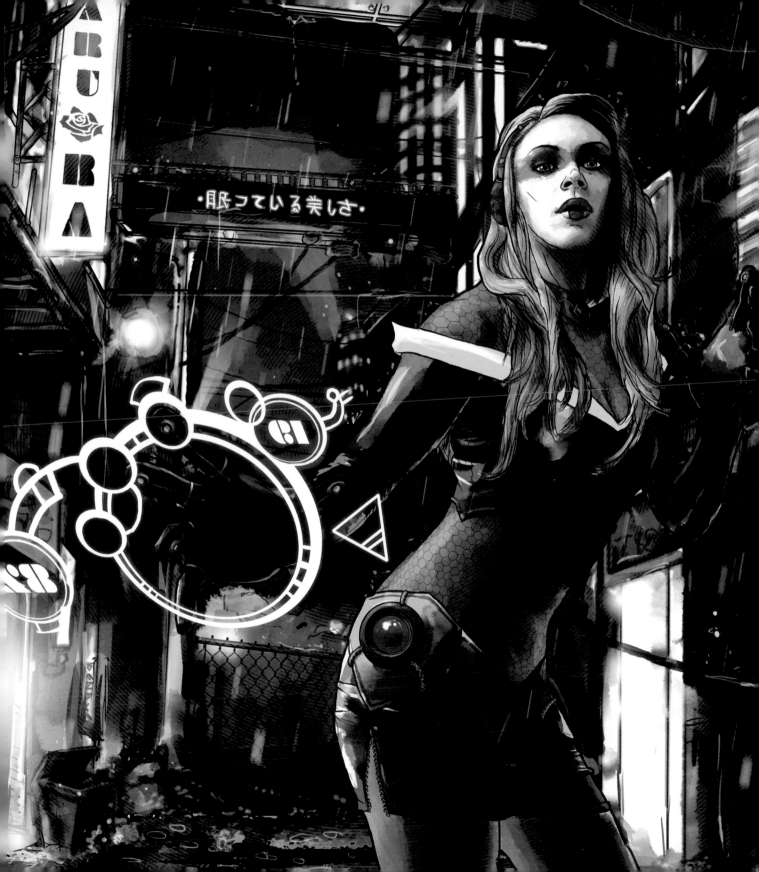

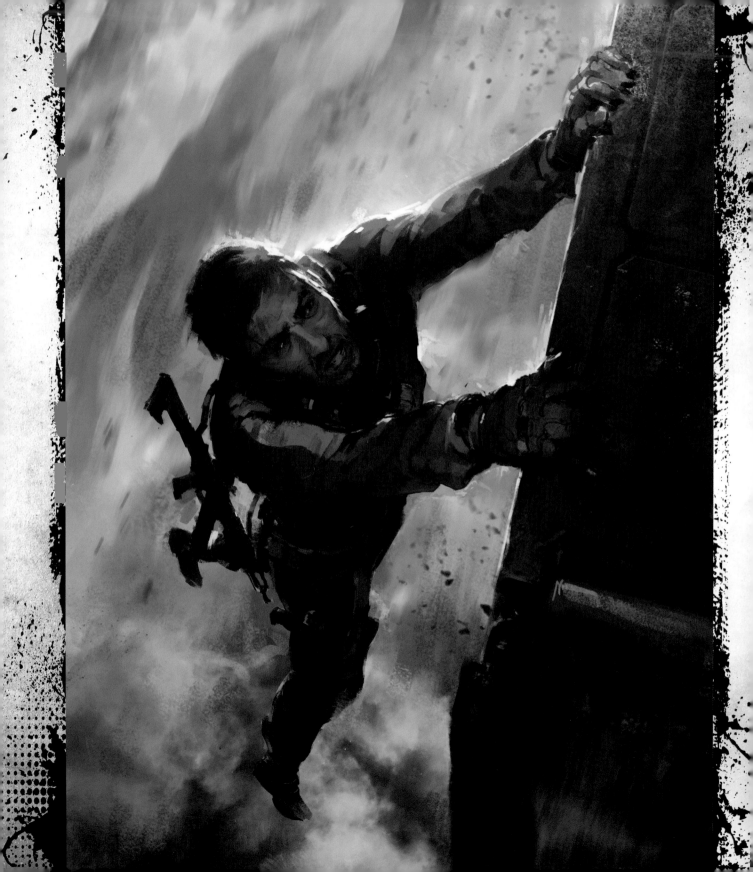

designer violence, social conditioning and brutal sex that it can almost be considered a black comedy. Very black: the film's teenage antihero, Alex, rapes a woman while belting out 'Singing In The Rain'.

Technically, the film isn't a dystopia, as 'society' dehumanizes Alex. But a society so casually willing to use such methods once will clearly do so repeatedly, in which case **A Clockwork Orange** is an 'origins of dystopia' film.

Laugh Until You Cry

If the jury's out on whether **A Clockwork Orange** was supposed to raise a wry smile or your stomach contents, other dystopias have been less vague. Yes, this grimmest of genres has produced its fair share of comedies. The first was from Richard Lester, the director of the Beatles' movies, whose absurdist **The Bed-Sitting Room** (1969) saw the bizarre survivors of nuclear war in Britain mutate into household objects.

Meanwhile, on BBC TV, comedy double-act The Two Ronnies envisaged a future where men cower under the might of a matriarchal totalitarian state in the serial 'The Worm That Turned' (1980).

War, What Is It Good For?

TV then played nuclear war for laughs in the ITV sitcom 'Whoops Apocalypse' (1982), which, despite featuring various heads of state trying to negotiate a way out of the

'In the year 2025, the best men don't run for president, they run for their lives…'
Stephen King,
'The Running Man'

Third World War, was less 'Yes Minister' and more 'American Dad' – the British Prime Minister wears a superhero costume throughout.

Ironically, director Terry Gilliam's **Brazil**, a wonderfully surreal 'comedy' twist on **Nineteen Eighty-Four**, ends up as a far more satisfying – and more harrowing – adaptation of Orwell's novel than the official movie adaptation the previous year. That's despite featuring Robert De Niro as a guerrilla heating-engineer.

Rubbish Movie

And what about a dystopian animated Disney movie? Sounds unlikely? How else can you describe the wonderful **WALL-E** (2008), a film that gives you two dystopias for the price of one? It starts with the eponymous droid conscientiously fulfilling his duties on an abandoned Earth piled high with rubbish. Then the action swaps to a spaceship containing the last remnants of humanity, who have all devolved into indolent, overweight buffoons. The ecological and social warnings are dished out with as much biting satire as any 'serious' dystopian movie, with the advantage that it also has two incredibly cute robots.

Nearly, But Not Quite

From the 1980s onwards, dystopian movies have become more and more conceptual. Admittedly, there have been

'It's about the third world trying to get into the first.'
Neill Blomkamp on 'Elysium'

'THX was a parable about where we were living in 1970. It wasn't about the future.'
George Lucas

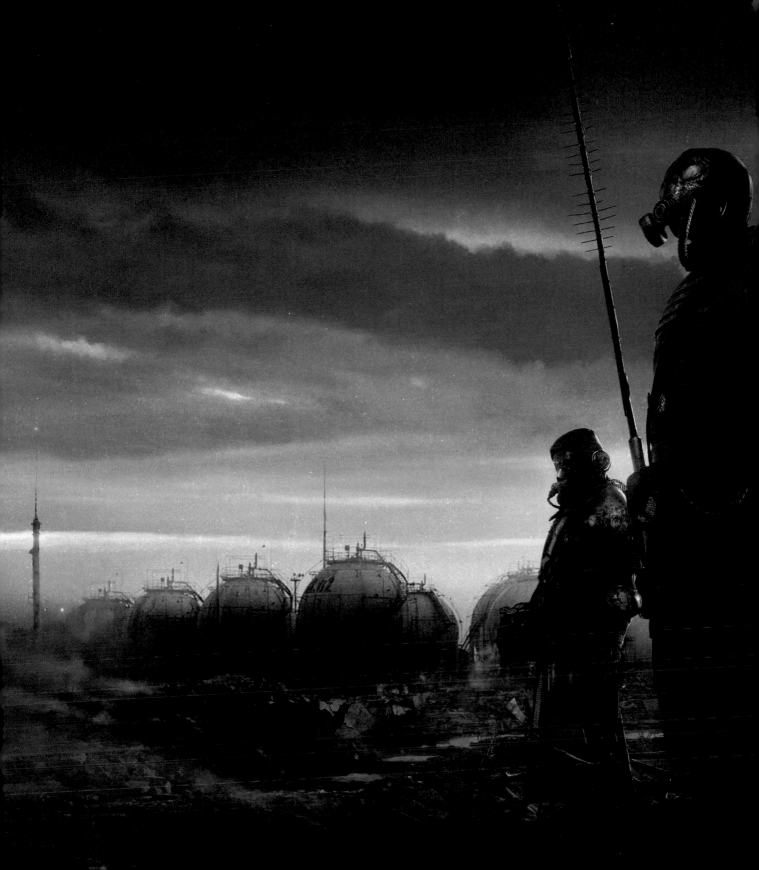

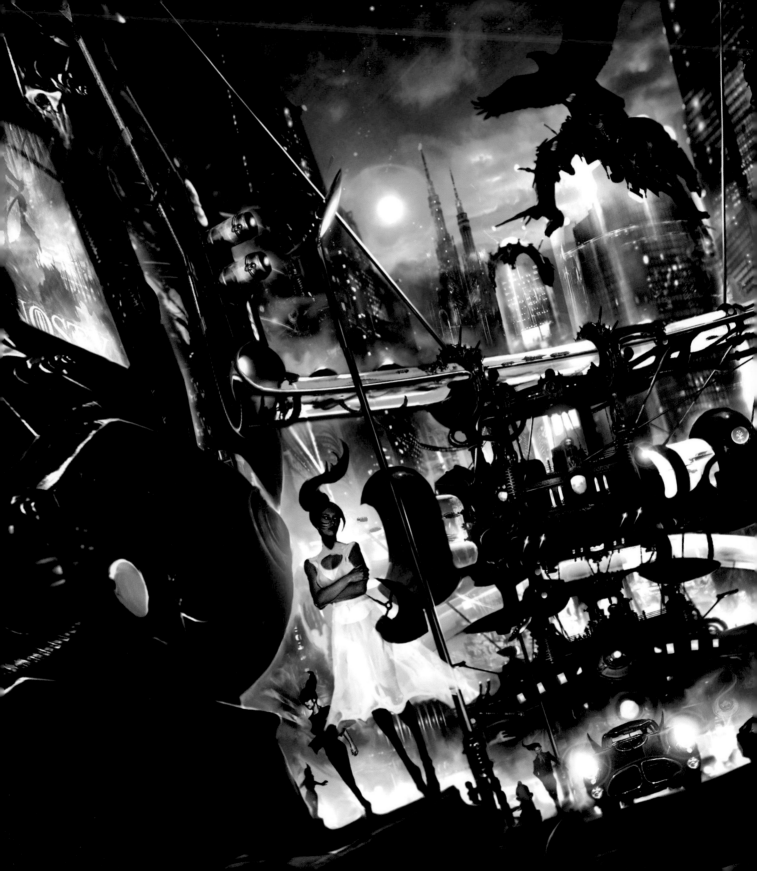

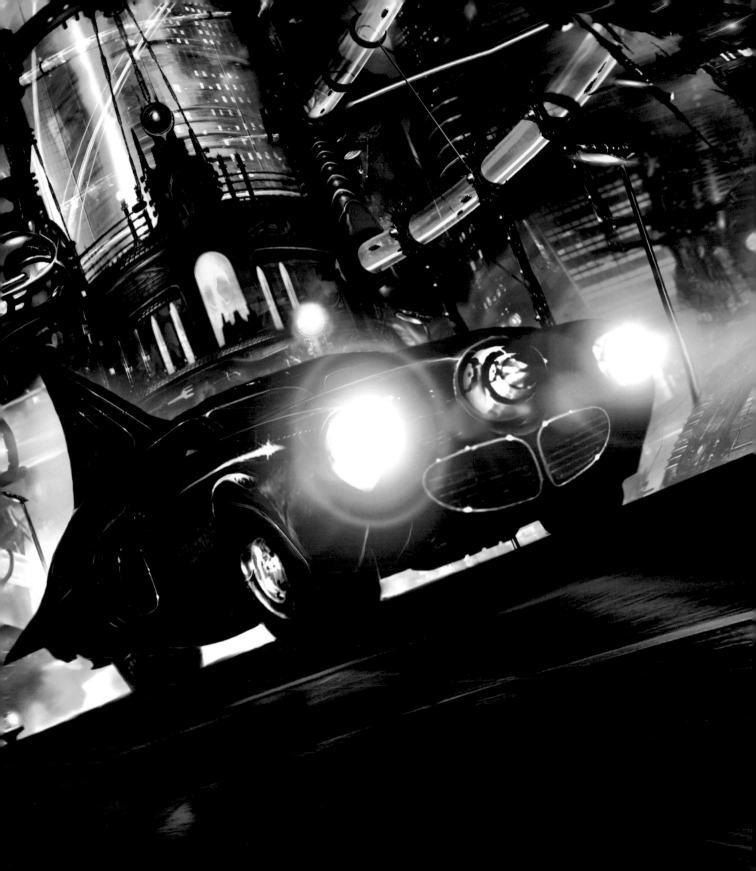

'I wanted to make a film that separated rich and poor. I thought it would be really interesting to take a corn-fed American white boy and put him in a Third World environment.'
Neill Blomkamp on 'Elysium'

plenty of movies that simply use some vaguely dystopian backdrop as a handy shorthand way of letting us know 'this is not a nice future', such as **Fortress** (1993) or **Demolition Man** (1993). Even **Blade Runner** (1982) is clearly set in a dystopia, but the Los Angeles of Ridley Scott's film feels little worse than New York today during a particularly heavy downpour. These are not films about dystopia, they just happen to be set there.

Dystopian Diversification

Other films have used dystopias in new and inventive ways. **The Terminator** (1984), taking its cue from the *X-Men* comic story 'Days Of Future Past', introduced time-travel into the equation, with a rebel from the dark future, in which the robots have risen against their human master, travelling back to the present to prevent it happening. Ironically, this meant that when 'Days Of Future Past' was made into a movie in 2014, it faced some criticism for being a **Terminator** rip-off.

The Matrix (1999), meanwhile, married virtual reality sublimation to the post-alien invasion dystopia scenario to produce … well, really cool fight scenes and bullet time, mainly.

Gene Genies

Andrew Niccol wrote and directed the coolly stylish **Gattaca,** about a future in which, if you're not genetically manipulated to be perfect, you're nothing. He later gave

MAN HAS MADE HIS MATCH
...NOW IT'S HIS PROBLEM

HARRISON FORD IS
BLADE RUNNER

JERRY PERENCHIO AND BUD YORKIN PRESENT
A MICHAEL DEELEY - RIDLEY SCOTT PRODUCTION
STARRING HARRISON FORD
IN BLADE RUNNER WITH RUTGER HAUER · SEAN YOUNG
EDWARD JAMES OLMOS SCREENPLAY BY HAMPTON FANCHER AND DAVID PEOPLES
BRIAN KELLY AND HAMPTON FANCHER VISUAL EFFECTS BY DOUGLAS TRUMBULL
VANGELIS ASSOCIATE PRODUCER IVOR POWELL PRODUCED BY MICHAEL DEELEY DIRECTED BY RIDLEY SCOTT

RESTRICTED
UNDER 17 REQUIRES ACCOMPANYING

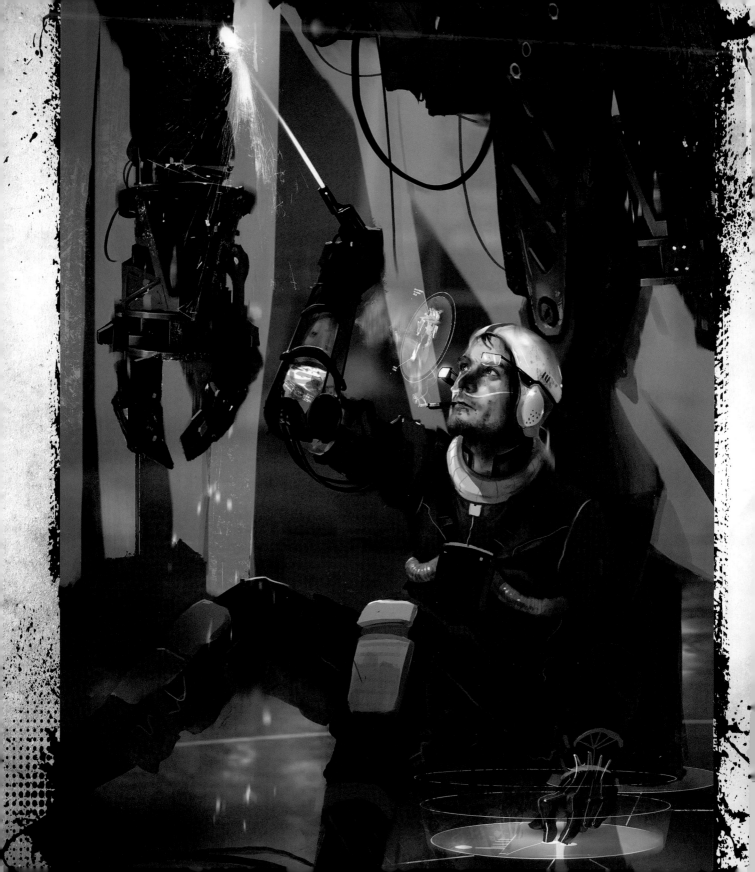

> '*Abby has a cock-eyed optimism, but somebody has to have it, otherwise it would just be death and despair.*'
> Julie Graham on her character in the BBC's 'Survivors'

us *In Time* (2011), in which everyone dies at the age of 26 unless they can buy more allotted time from somebody willing to give up theirs.

Equilibrium (2002) is set in a totalitarian future in which emotions are illegal; in *Children Of Men* (2006), babies stop being born; and in *Doomsday* (2008), Scotland has been turned into a massive, walled-in quarantine zone. And you thought North of the Wall in *Game Of Thrones* was bad.

Us And Them

2013 gave us two very stylish and very different post-apocalyptic movies. South African director Neill Blomkamp set his apartheid-metaphor alien movie *District 9* (2009) against a vaguely dystopian-feeling backdrop, but his follow-up, *Elysium* (2013), was the real deal. This was full-on allegory; it had the downtrodden proles eking an existence on a scuzzy Earth, and the rich overlords living in luxury on a space-ship. Oh, and some cool exoskeletons.

Tom Cruise starred in *Oblivion* as a droid repairman on a deserted post-apocalyptic Earth. We can't tell you what caused the apocalypse because … spoilers!

After The Fall

Traditional post-apocalyptic films have survived, however. *Mad Max 2* (1981) and *Mad Max Beyond The Thunderdome* (1985) were both set post-nuclear war,

spicing up the usual 'wandering around dusty landscapes' shtick with some top-notch carmageddon. *I Am Legend* was the third adaptation of Richard Matheson's novel (after *The Last Man On Earth* (1964) and *The Omega Man* (1971)). Pointlessly, the film swaps the novel's vampires for zombies and introduces more characters so that Will Smith isn't the 'legendary' last man on Earth. The vampires instead moved to *Daybreakers* (2009), where they've taken over the world but are in danger of sucking it dry of blood.

One-off Dystopian Episodes

TV has the advantage that it can produce both specifically dystopian shows – like the standard post-apocalyptic fare of 'Jericho' (2006–08, nuclear bomb), 'Jeremiah' (2002–04, plague) and both versions of 'Survivors' (plague again) – and dystopian episodes of otherwise usually non-dystopian shows.

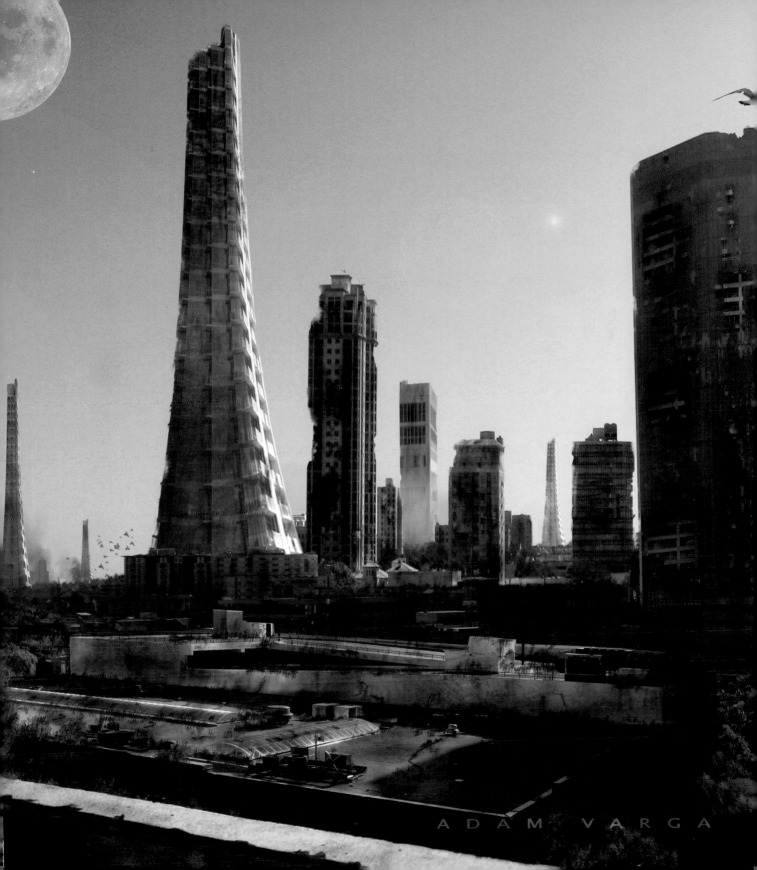

ADAM VARGA

The best example is the evil 'mirror universe' introduced in the original 'Star Trek' (1966–69), which was then expanded and used in 'Star Trek: Deep Space Nine' (1993–99) and 'Enterprise' (2001–05). These occasional episodes involve glimpses into an alternative universe, featuring evil versions of the shows' regular characters, and the men usually have more facial hair.

Evil Twins

Other dystopian episodes include 'Doctor Who's' 'Inferno' (1970), another evil alternative-timeline story, and 'Turn Left' (2008), in which the Doctor's then-companion, Donna, lives an alternative Doctorless future in which an atomic bomb is dropped on London, creating a military-run state.

'Buffy The Vampire Slayer' gave us 'The Wish' (1998), in which a wish misfires and creates a dystopian version of the Buffy universe. The 'Heroes' episode 'Five Years Gone' (2007) was yet another version of 'Days Of Future Past', with super-powered mutants being persecuted and killed in an alternative totalitarian future.

Fringe Benefits

Joss Whedon's TV show 'Dollhouse' (2009–10) had a brace of interrelated episodes which capped each of its two seasons – 'Epitaph One' and 'Epitaph Two: Return'. They reveal a glimpse into the near future, showing the dystopian results of the failure of the Dollhouse project.

'Who among us hasn't been frustrated with a five-minute blackout, much less a permanent one?'
Eric Kripke, creator of 'Revolution'

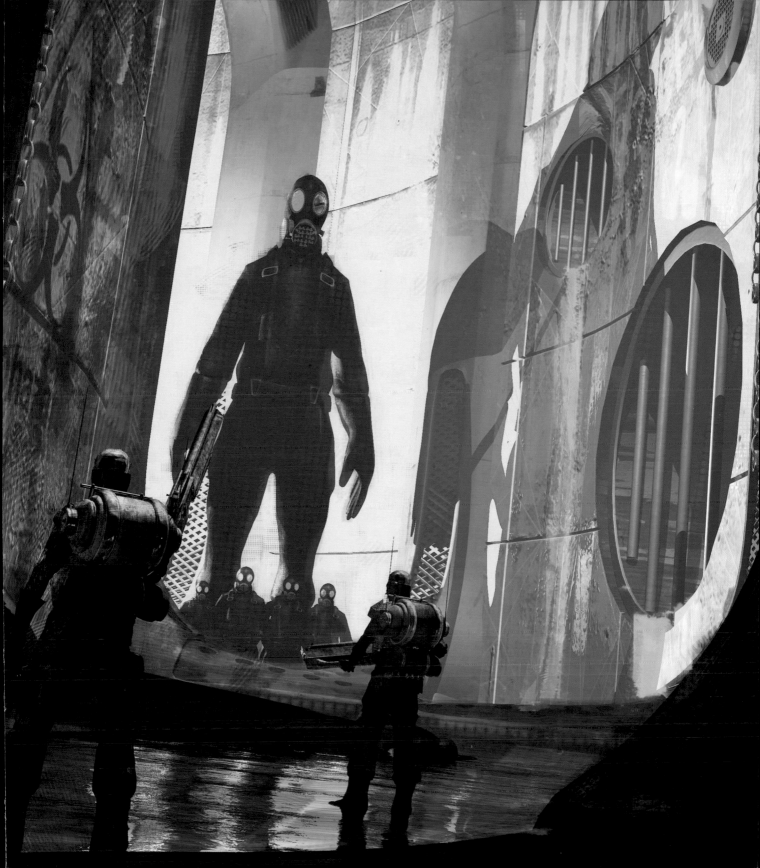

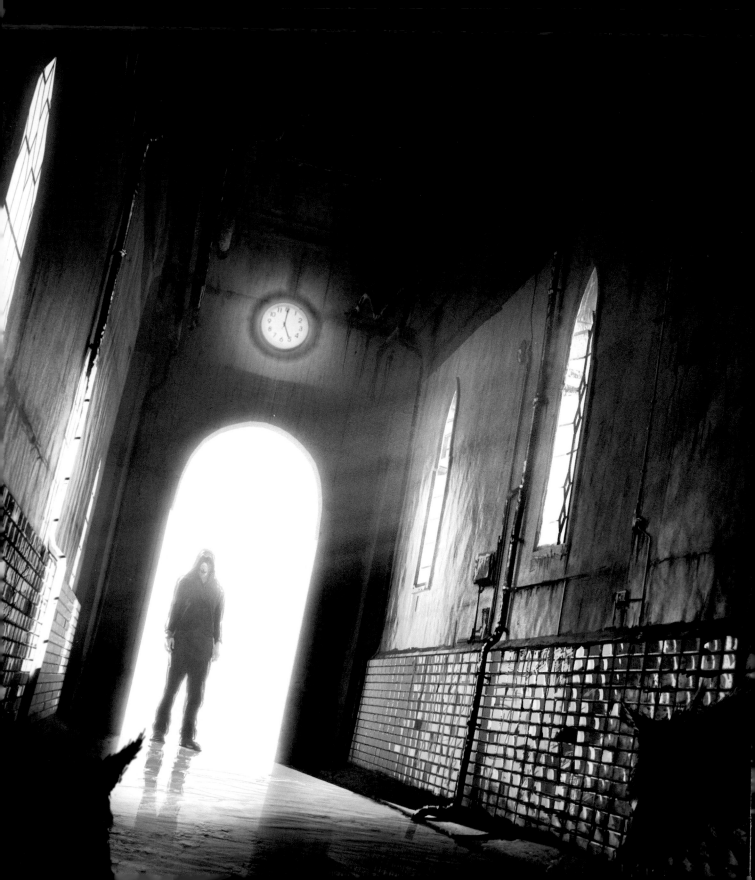

The mysterious time-travel anomalies in 'Primeval' (2007–11) also revealed a future apocalypse, plus a cybernetically enhanced new breed of dinosaur.

'Fringe' (2008–13) went one better by having its entire final season take place in a dystopian future, where the bald, telepathic, time-warping Observers have seized control of Earth and are changing its atmosphere.

Walk On The Wild Side

One of the biggest TV hits of the 2010s, though – dystopian or otherwise – has been the phenomenally successful 'The Walking Dead' (2010–). The series premise is hardly ground-breaking: it's your standard zombie apocalypse – humans fight to survive in a broken world full of brain-eaters.

The reason this cable channel show achieves the kind of ratings major networks would kill for is simple, though: all the imaginatively gory zombie kills. Well, that and the fact that, like the comic, it creates riveting human drama around the central concept and plays the whole thing astonishingly straight. It's utterly, scarily believable.

Have You Seen This Series?

The shows keep coming. 'The Tribe' (1999–2003) was a New Zealand series aimed at teens, about kids surviving in a world without adults (but with lots of multicoloured hair dye). 'The Sarah Connor Chronicles' (2008–09) was a popular but short-lived spin-off from **The Terminator**

'I want to know what post-apocalyptic future was caused by "Two And A Half Men".'
Joss Whedon

series of films. The Canadian show 'Continuum' (2012–) is another take on **The Terminator,** with a cop from a corporate-dominated dystopian future time-travelling to the present day and wondering if she should change the future or not. Except, over the ensuing seasons, it's become a lot more complex than that.

The End Isn't Nigh

Then there are two religious-themed shows. 'The Leftovers' (2014–) tells the story of those left behind after one tenth of the world's population simultaneously vanishes in an event some are convinced is divine. And in 'Dominion' – a spin-off from the (frankly not very good) film **Legion** (2010) – humanity has to deal with the aftermath of a war between angels, because angels make an awful lot of mess, apparently.

With those shows, and the **Divergent** films due for release in the next few years, the future for dystopian films and TV is looking anything but bleak.

'When we were shooting it I thought we were making a comedy. A black comedy.' Malcolm McDowell on 'A Clockwork Orange'

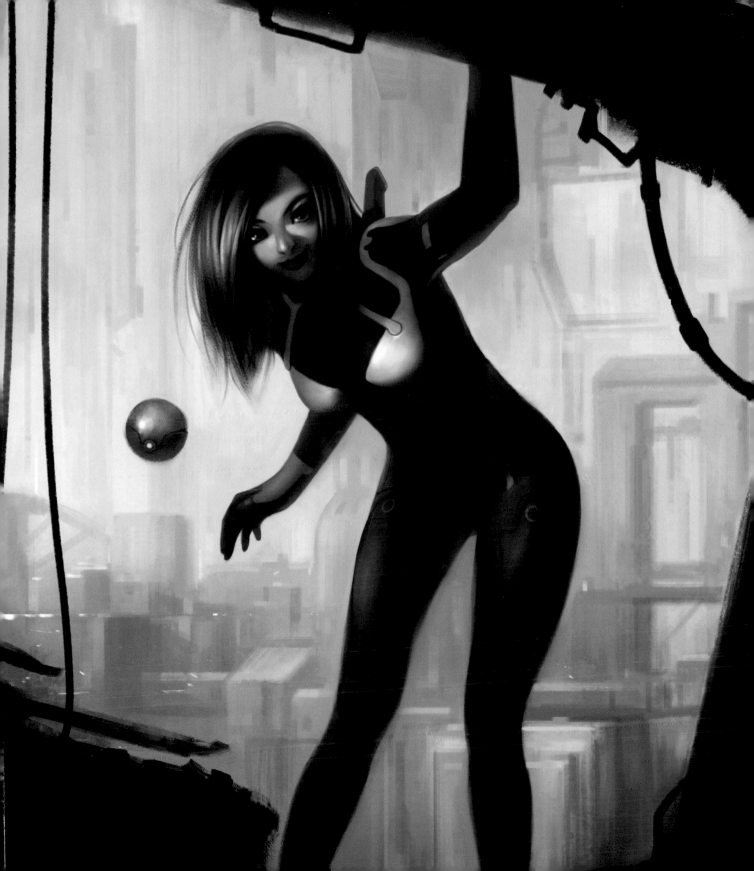

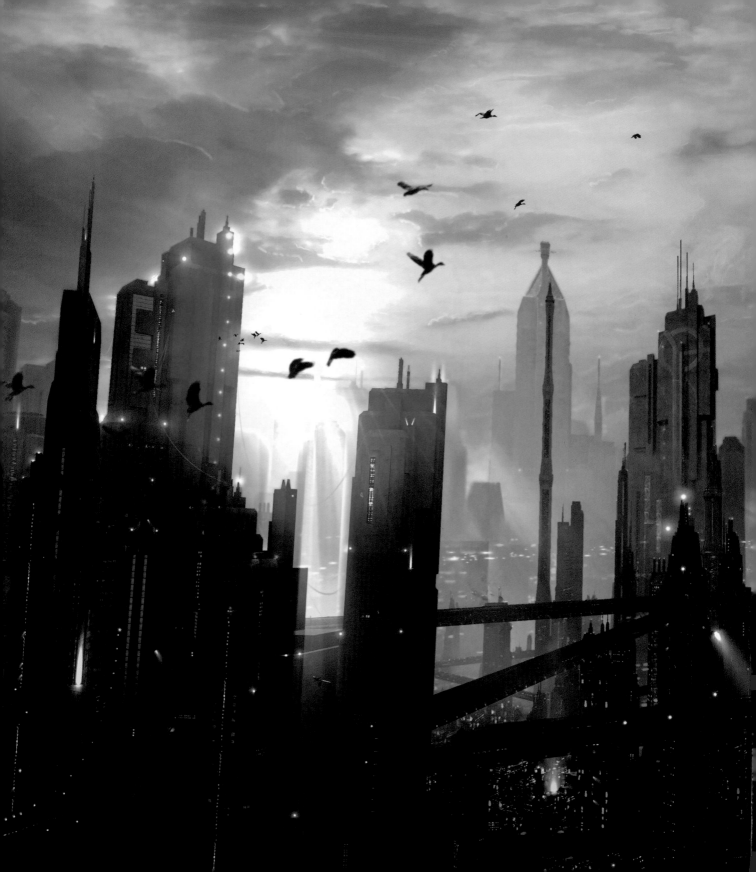

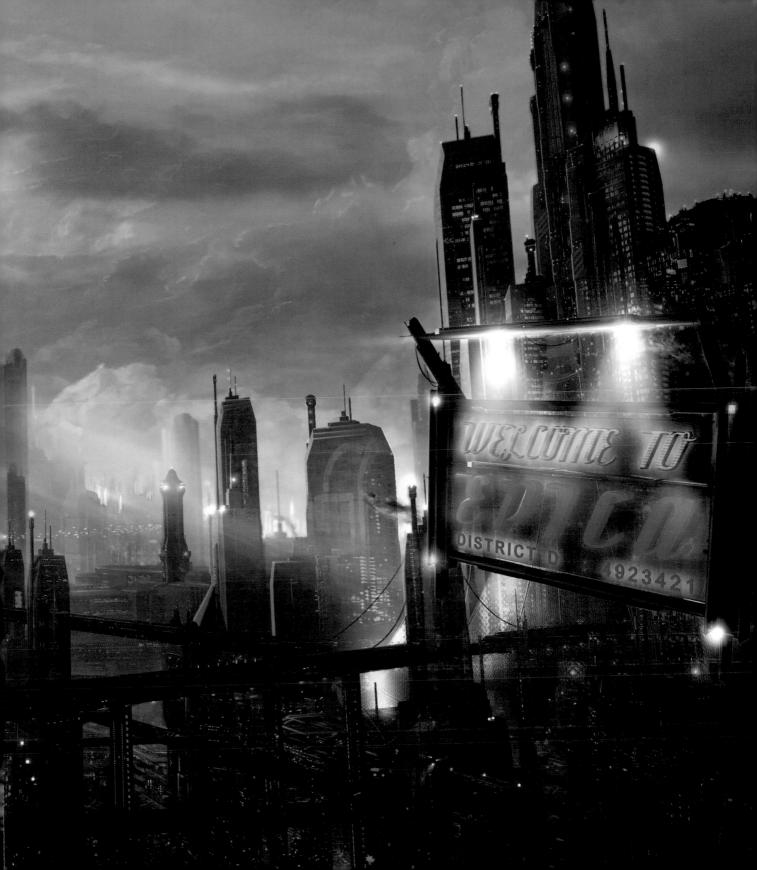

Drawn To The Dark

From paintings to album and book covers, to film posters and concept designs, the art of dystopia is all about finding beauty in decay. The subject matter is grim by definition – crumbling cities, desolate deserts, downtrodden crowds – but artists still have to create images we want to see on our walls. Shelves are screens.

The best dystopian artists have produced work that has become icons of a dark future: Syd Mead's future LA in **Blade Runner**; David Lloyd's totalitarian London in **V For Vendetta**

(1982–89); Richard M. Powers' bleak and twisted covers for J.G. Ballard's novels.

Reinventing The Future

A new generation of artists is helping Hollywood reimagine dystopia in films such as **Cloud Atlas** (2012) (with concepts for a future Korea designed by Jonas De Ro) and **Elysium** (for which Ben Mauro and Aaron Beck provided input).

Fritz Lang may not have employed renowned Dutch artist Paul Citroen to

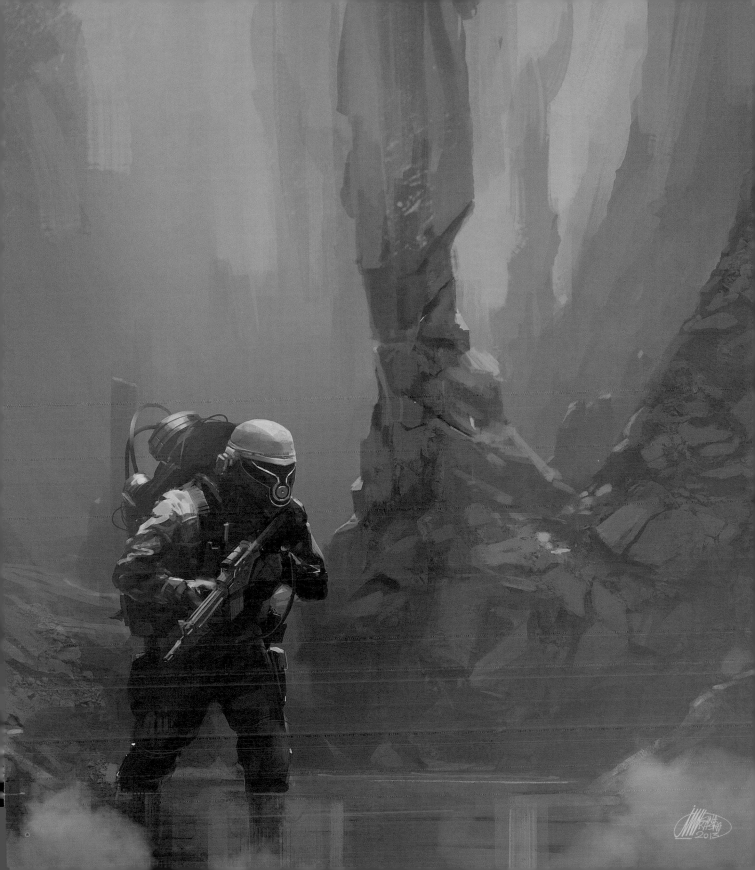

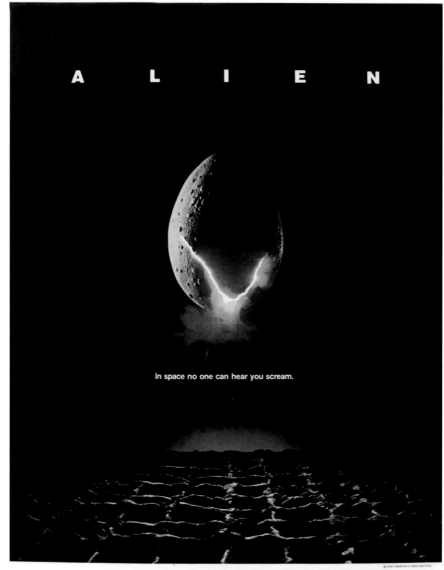

design **Metropolis**, but when you see his most famous work, a photomontage also called **Metropolis**, depicting a crush of buildings all piled on top of each other, you can clearly see his influence on the film. And so the relationship between dystopian artist and dystopian filmmaker began.

The Fine Art Of Dystopia

The great granddaddy of dystopian art was Hieronymus Bosch (c. 1450–1516), whose elaborate, intricately detailed and deeply disturbing depiction of Hell in **The Garden Of Earthly Delights** (1503–04) was the most extreme example of a body of work filled with death, destruction and sinners doing naughty things.

Though Bosch's apocalyptic work is not, strictly speaking, dystopian, the imagery has had a long-reaching influence. Echoes of Bosch can be detected in the future world of **The Terminator**, in the decaying prison planet of **Alien 3** (1992), in the depraved and violent world of Kubrick's **A Clockwork Orange**, and on any number of heavy-metal album covers.

The Victorian Blockbuster

Religion was also the driving force behind the work of the nineteenth century's greatest exponent of the apocalyptic painting, John Martin (1789–1854). The Michael Bay of his day (the public loved him; the critics not so much), he created vast canvases full of Hell and damnation, fire and brimstone, with wonderfully lurid names like **The Seventh Plague Of Egypt** (1823), **The Great Day Of His Wrath**

'It is not easy to believe in the survival of civilisation… I think one must continue the political struggle, just as a doctor must try to save a patient who is probably going to die.'

George Orwell

'I was once asked by somebody if writing Batman was like holding a Ming vase ... I said, "No, it's like holding a big-ass diamond that you can't break. You can throw him against the ceiling, against the floor, anywhere, and you just can't break Batman."'

Frank Miller

(1851–53) and **The Destruction Of Sodom And Gomorrah** (1852). He then took them on tour around the world and wowed audiences with them, enhancing the experience with gimmicky lighting displays and dramatic oratory.

Pulp Fiction

In the twentieth century, fine art and dystopia rarely mixed, though the work of some surrealists, particularly the twisted landscapes of Salvador Dalí (1904–89), can be loosely described as dystopian.

Instead, most dystopian art was found on the covers of sci-fi novels and magazines, such as **Amazing** and **Fantastic**. Few artists could be described as dystopian specialists, but if they wanted to make a living, they would have to turn out a dystopian vista or two regularly. This included such dependables as Frank R. Paul, who could produce great mass destruction when required, and Lloyd Birmingham, who specialized in forlorn-looking figures lost in technology.

What Does This Spaceship Tell Us?

Ed Valigursky – who provided many early Philip K. Dick covers – was your man for figures dwarfed by bleak landscapes. Humans, however, were rare in Dean Ellis's work, but his impassive cities and bleak landscapes graced many a book cover. In many ways, Ellis can be seen as a forerunner to Mark Salwowski's distinctive work on Iain M. Banks's covers; the vast structures

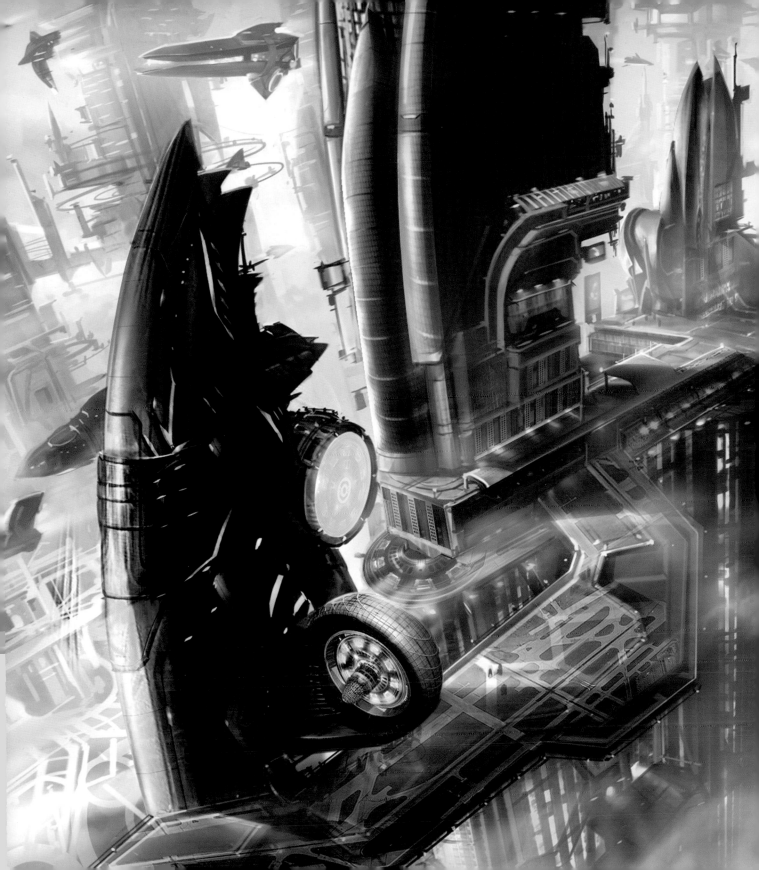

aren't just vast structures – as in the work of, say, Chris Foss – but instead seem to take on an almost impressionistic quality, hinting at themes of disconnection and isolation in the novels.

Power Ballards

One of the other cover-creating legends of the golden age of science fiction was the astonishingly prolific Richard M. Powers, whose unfussy, occasionally abstract work graced literally hundreds of books from the 1940s to the 1970s, including a nightmarish, almost surreal cover for Arthur C. Clarke's part-dystopian ***Childhood's End*** (1953).

More significantly, he provided the covers for 14 J.G. Ballard books, which included London in ruins for ***The Wind From Nowhere*** (1961), a man dwarfed by nature for ***The Drowned World*** (1962), and a wonderfully on-the-nose (and not quite in keeping with the novel inside) interpretation of the title for ***The Burning World*** (1964).

Progressive Dystopia

During the 1960s and 1970s, dystopian art had a new outlet – the album cover, usually the prog rock album cover. The king of the prog rock cover was Roger Dean, whose name will be for ever linked to the band Yes. He designed their almost-unreadable logo, after all. ('If someone has to read it, you're in trouble,' he told a record company boss. 'They have to recognize it, not read it.')

His Yes covers are certainly fantasy, with floating islands and gravity-defying water, but they look far too much like a nature documentary about Narnia to be called dystopian.

Demons And Wizards

Some of Dean's other album covers, though, delve further into dystopian themes, including **Demons And Wizards** (1972) and **The Magician's Birthday** (1972) for Uriah Heap; **Bedside Manners Are Extra** (1973) and **Cactus Choir** (1976) for Greenslade; and especially Billy Cox's **Nitro Function** (1971), with its weird flying craft-hunting horse riders, like **The Tripods** meets **Lord Of The Rings**.

But throughout, even when there are 'demons and wizards' on Dean's covers, there remains something cosy and kitsch about his dark fantasy lands. He admits himself that nature is his main inspiration and once stated, 'Very little in most of my paintings is fantasy.'

Weirder Landscapes

In the late 1970s, when director Ridley Scott was looking for inspiration for a new monster movie he was making, he turned to Swiss artist H.R. Giger. **Alien** (1979) made Giger a household name, but it was a tiny part of his dark, weird output. Scott was attracted by Giger's bizarre landscapes constructed from genitalia ('Penis Landscape' being the most infamous), but Giger's dystopian credentials are also evident in his 'biomechanical' work, such as **Electromechanic VIII**, which savagely blends human

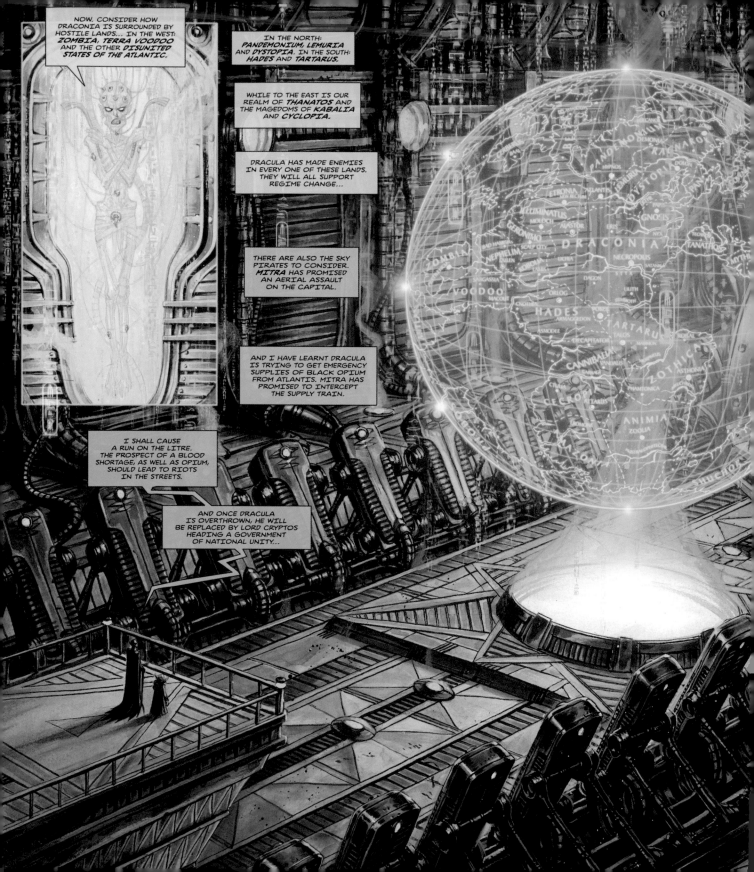

NOW. CONSIDER HOW DRACONIA IS SURROUNDED BY HOSTILE LANDS... IN THE WEST: *ZOMBIA*, *TERRA VOODOO* AND THE OTHER *DISUNITED STATES OF THE ATLANTIC*.

IN THE NORTH: *PANDEMONIUM*, *LEMURIA* AND *DYSTOPIA*. IN THE SOUTH: *HADES* AND *TARTARUS*.

WHILE TO THE EAST IS OUR REALM OF *THANATOS* AND THE MAGEDOMS OF *KABALIA* AND *CYCLOPIA*.

DRACULA HAS MADE ENEMIES IN EVERY ONE OF THESE LANDS. THEY WILL ALL SUPPORT REGIME CHANGE...

THERE ARE ALSO THE SKY PIRATES TO CONSIDER. *MITRA* HAS PROMISED AN AERIAL ASSAULT ON THE CAPITAL.

AND I HAVE LEARNT DRACULA IS TRYING TO GET EMERGENCY SUPPLIES OF BLACK OPIUM FROM ATLANTIS. MITRA HAS PROMISED TO INTERCEPT THE SUPPLY TRAIN.

I SHALL CAUSE A RUN ON THE LITRE. THE PROSPECT OF A BLOOD SHORTAGE, AS WELL AS OPIUM, SHOULD LEAD TO RIOTS IN THE STREETS.

AND ONCE DRACULA IS OVERTHROWN, HE WILL BE REPLACED BY LORD CRYPTOS HEADING A GOVERNMENT OF NATIONAL UNITY...

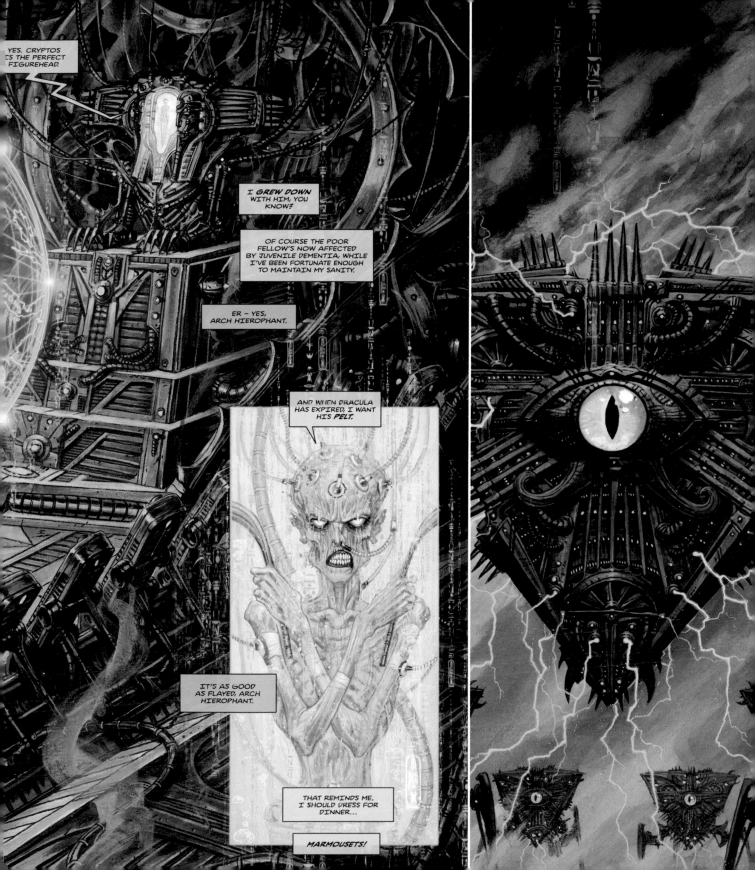

> *'I think Dredd is a very strong character, and very iconic. You can recognise Superman by the shield on the chest, Batman by the hood and Dredd by the helmet.'*
>
> Carlos Ezquerra

and machine in disturbing ways, and **Birth Machine** with its goggle-eyed babies as bullets in a revolver.

Crazy Like A Swiss Artist

Giger was another artist not averse to painting the odd album cover too – his creation for **Brain Salad Surgery** (1973) by Emerson, Lake & Palmer is a wonderfully dystopian-esque depiction of a skull in a vice being examined by some bizarre medical instrument. 'My paintings seem to make the strongest impression on people who are, well, who are crazy,' he admitted in one interview.

Oddly, the cyberpunk revolution of the 1980s produced few classic dystopian book covers, as publishers seemed to favour abstract images and typography. But dystopian art was finding new outlets in film and comics.

Panel Games

Judge Dredd's Mega-City One is now accepted as a quintessential dystopian city of druggies, cults, gangs, social inequality and killer robots, but when 2000 AD launched the strip in issue 2 in 1977, it actually looked like quite a nice place to live. The true underbelly was only revealed as writers like Pat Mills realized that (a) a dysfunctional city was more fun to write about, (b) it enabled them to be more bitingly satirical, and (c) artists like Brian Bolland and Carlos Ezquerra knew how to draw really cool scuzzy cities and weird, dark characters. It's not the place for a city break.

NATALIE PORTMAN HUGO WEAVING

V FOR VENDETTA

> '*The important thing about that mask is that it's used on a widespread level by many people who just want to use it as an all-purpose symbol of resistance to tyranny…*'
> David Lloyd, 'V for Vendetta' artist

Fight For The Future

The next landmark in comic dystopias was the two-issue tale in 'Uncanny X-Men: Days Of Future Past' (1981), a time-travel tale in which the super-team had to prevent a dystopian future in which mutants are hunted and killed. Its influence has stretched far beyond comics, with everything from **Terminator** to **Heroes** taking inspiration from it. The evocatively grimy, scratchy, rubble-strewn future was brilliantly drawn by John Byrne.

A year later, Alan Moore gave us a totalitarian future Britain in **V for Vendetta**, complete with invasive computer 'security', all rendered in stark beauty by artist David Lloyd.

And There's Moore

Comic legend Frank Miller gave Gotham City a dystopian makeover in 'The Dark Knight Returns' (1986), to suit his new psychologically scarred and bitter take on Batman. Howard Chaykin set 'American Flagg!' (1983–89), after the delightfully named 'Year Of The Domino', in a consumer-obsessed United States controlled remotely from a government on Mars. His eponymous hero is an ex-TV star forced to become a 'Plexus Ranger'. And in Mark Millar's 'Wanted' (2003–06), the world is run by super-villains. 'Transmetropolitan' (1997–2002) is a cyberpunk series about a gonzo journalist set in an archetypal dystopia constructed with vitriolic passion from everything writer Warren Ellis hates about the modern world.

'Some people would say my paintings show a future world and maybe they do, but I paint from reality.'
H.R. Giger

Where, When and Y

Brian K. Vaughan's 'Y: The Last Man' (2002–08) was the coolest comic on the block in the early twenty-first century. In it, all male mammals in the world die simultaneously, except Yorick and his pet monkey Ampersand. That's the start of a sprawling, globetrotting, post-apocalyptic epic that wittily and cleverly explores the ramifications of a world without men.

Now that's finished, the comic book that everybody wants to read is Robert Kirkman's zombie blockbuster 'The Walking Dead' (2003–), which was massive even before the TV show. Charlie Adlard's no-nonsense monochrome art throughout has been one of the big attractions.

Straight From Tablet...

On the big screen, the CGI revolution means that an artist's vision can make it to the screen more intact than ever before. What the artists paints, the CGI wizards can make come alive, especially if the artists paint digitally.

So you get filmmakers like the Wachowskis calling on Jonas De Ro to help envision their dystopian future in **Cloud Atlas**. You only need to look at a gallery of his painstakingly detailed and beautifully lit imaginary cities to see why. 'I am able to create massive environments and complex characters to a level of quality and speed I would never have achieved with traditional means,' he says of painting digitally.

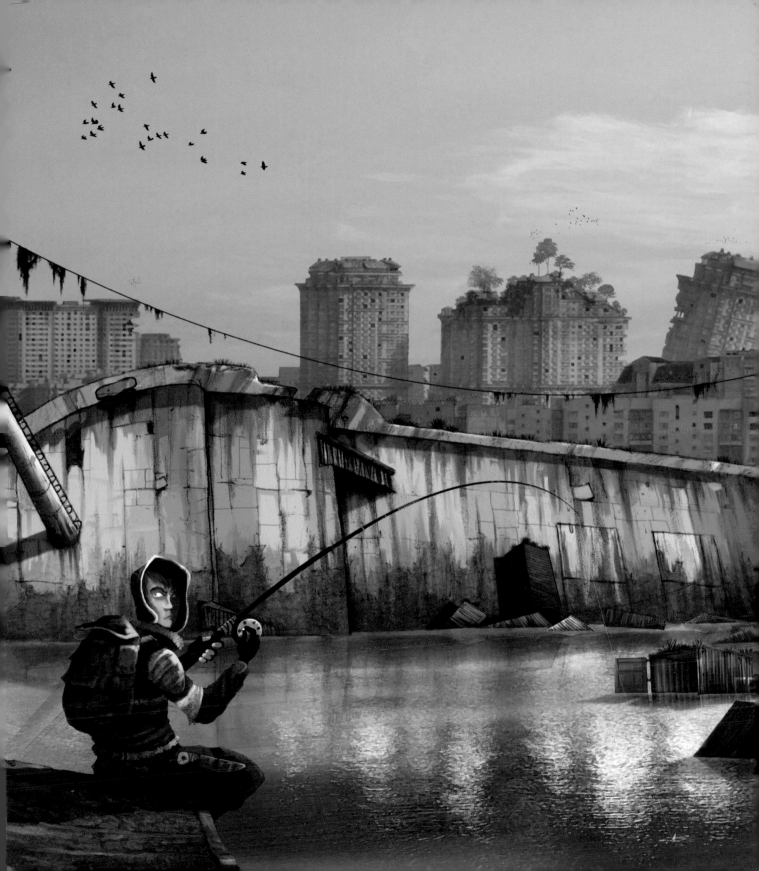

They Can Rebuild Him

American Ben Mauro is a modern master of cyberpunk art, but his love of melding machine to man and cool-looking robots made him the perfect fit for director Neill Blomkamp's **Elysium**. Also working on that dystopian satire was Weta Workshop's Aaron Beck, another young concept designer with a clear love of cyborgs, mechanoids and futuristic hardware. 'It was a lot of fun as a designer to have the two worlds of the film to develop, the gritty slums of third-world Earth and the clean futurism of Elysium,' he said in an online interview.

Dystopia Now!

Other contemporaries are also approaching dystopias in new and novel ways. There's Billy Tackett, who specializes in bizarrely over-the-top zombie portraits. At the other end of the spectrum, San Francisco artist John Wentz produces eerie, atmospheric post-apocalyptic work, often featuring shadowy people in gas masks, in paintings destined to be hung in art galleries.

Russian Vladimir Manyuhin, meanwhile, released a series of striking images in 2012 called **Life After The Apocalypse**, in which he used photo manipulation to create dystopian versions of real-world locations, such as Times Square and the Kremlin. Simple idea: chilling results.

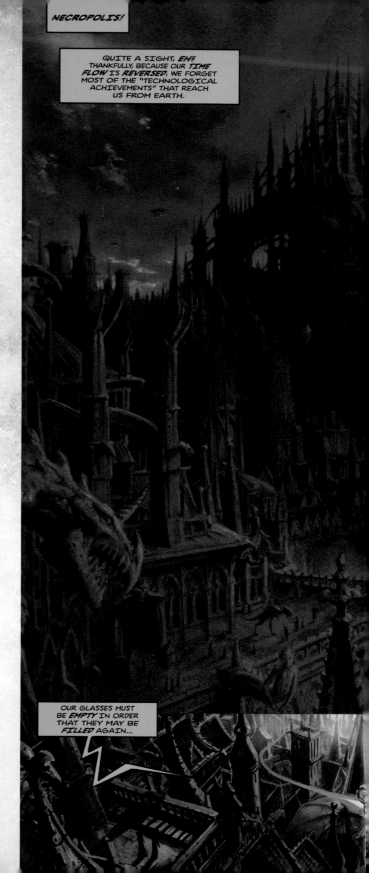

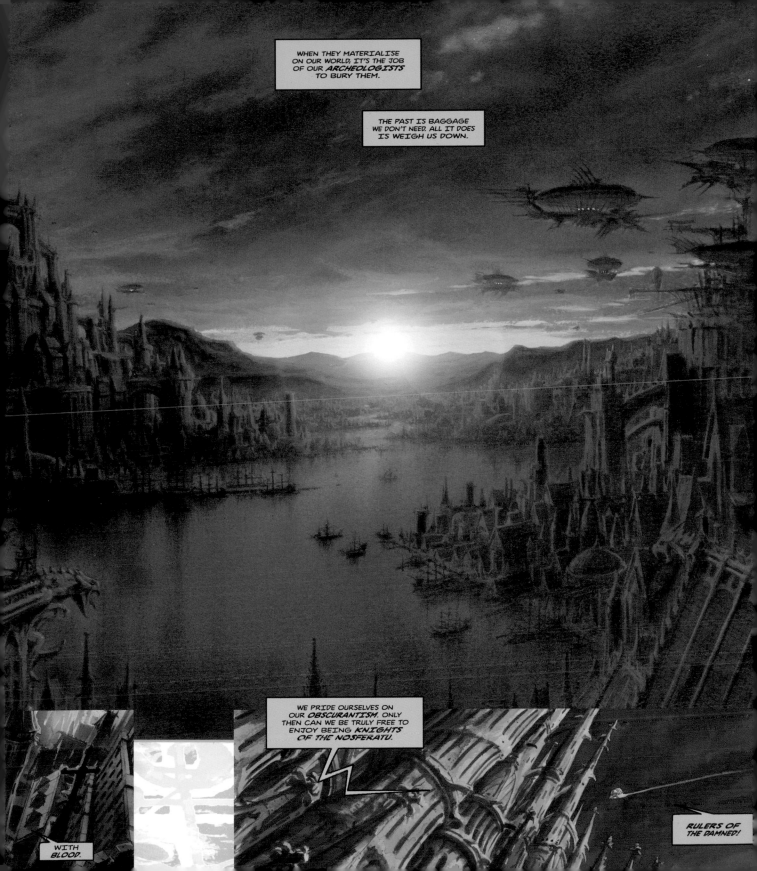

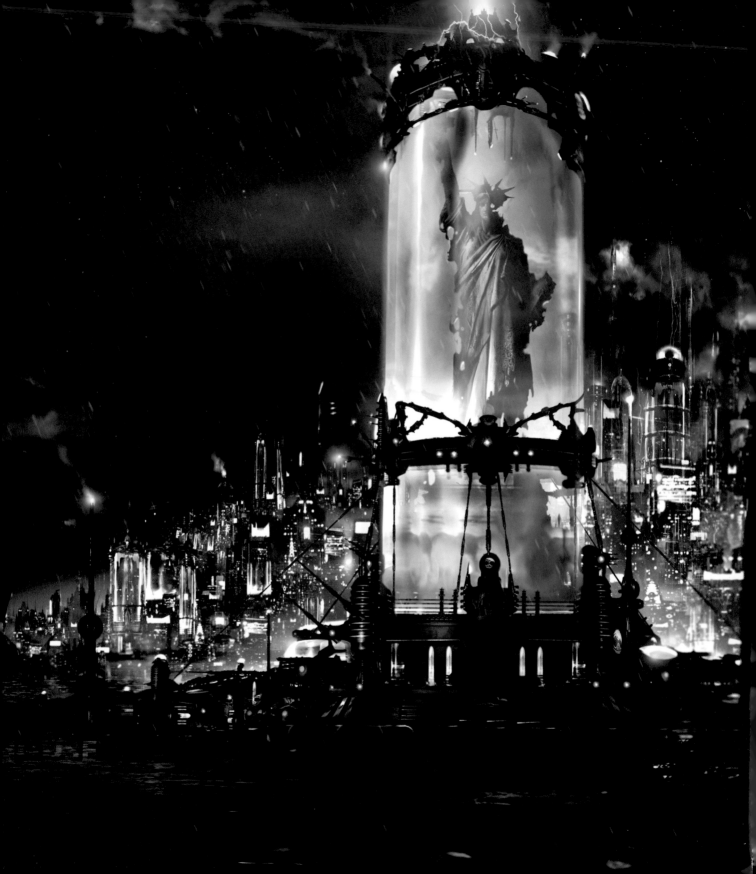

'Suddenly you saw that he was much more than just a character. That he was indeed a mythological figure…'
George Miller on 'Mad Max 2'

Tankers In The Sky

Another Russian giving dystopia a makeover is Alex Andreev (see p16). His evocative digital paintings add a sense of wit and weirdness to his dramatic dystopian vistas. Like Roger Dean, he loves heavy objects that defy gravity, but unlike Dean's love of nature, his work is filled with massive hardware reminiscent of Chris Foss's work.

'It sounds paradoxical,' he says, 'but digital art attracts me because it is free of technological influence. While in traditional arts, technologies dramatically limit the artist, in digital painting, I sit in front of a screen, grab the stylus and see the result immediately.'

Anarchy In The UK

Also from Russia, concept artist Alexander Ovchinnikov (see p.53) brings a fantasy role-playing game flavour to his dystopian characters and landscapes, which isn't surprising, as he lists Games Workshop, Black Library and various games companies among his clients.

In Britain, Bristol-based Shaun Gardner has created an eclectic bunch of dystopian works (see p.25 and p.122), the centrepiece of which is the quite stunning digital comic 'The Boy With Nails For Eyes' (see p.54). The future's not bright, but these artists make it look amazing.

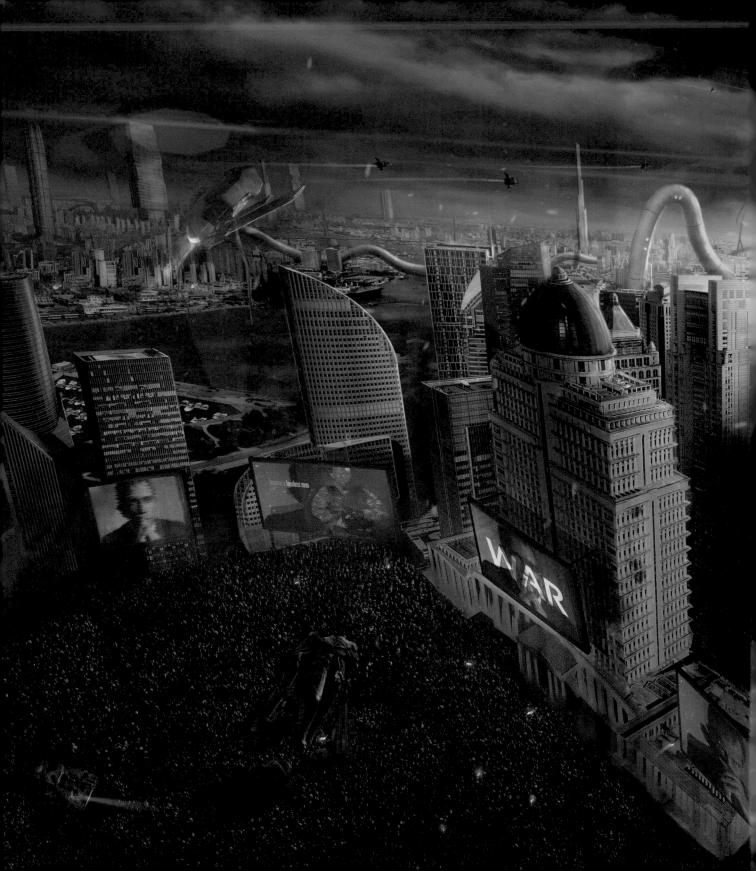

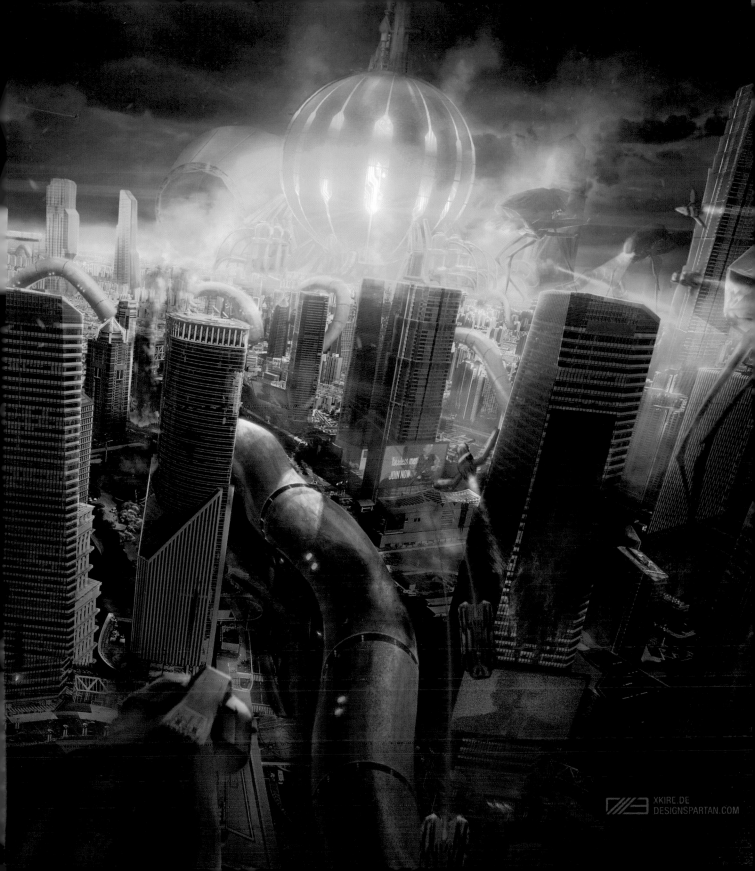

Dystopia Is Everywhere

It's 1984. Ranks of bald-headed men and women in grey overalls march in unison into a large arena, where a face on a giant screen intones slogans at them. A woman in red and white runs into the arena and throws a hammer into one of the screens. It's the start of a revolution: a computer revolution. But this is not a film or a TV show. This is the film that launched the Apple Macintosh, directed by Ridley Scott.

Dystopian themes have penetrated deep into the zeitgeist, influencing not only TV shows, books and movies but also advertising, music, computer games and even fashion.

Dressed For The Apocalypse

Yes, fashion. In 2013, Dutch designer Martijn van Strien unveiled his 'Dystopian Brutalist Outerwear' collection for Dutch Design Week – incredible thick black coats made from heavy-duty tarpaulin, with no visible seams. 'After the economic downfall and the decline of our society, life on this planet will be tough and unsure,' he reasoned. 'For people to survive, they will need a protective outer layer.' Apocalypse-proof or not, some of his 'outerwear' later turned up in the 2014 Lady Gaga video for 'G.U.Y'.

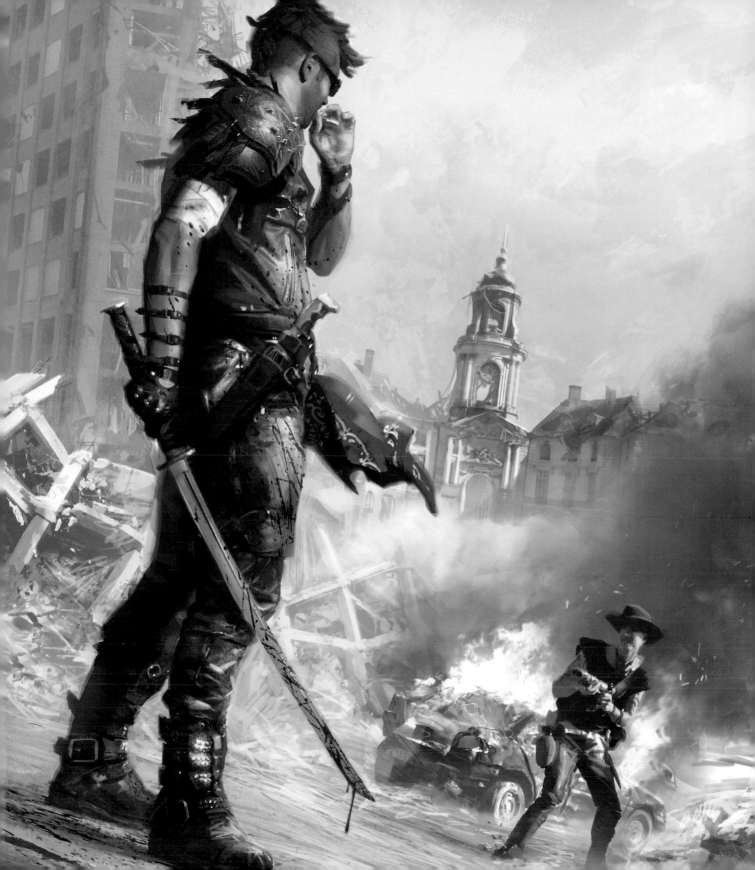

Blurred Visions

But that was far from the first combination of pop promo and dystopia. When **Highlander** director Russell Mulcahy teamed up with Duran Duran, they created the pop videos for 'Union Of The Snake' (1983, conceived by Mulcahy) and 'Wild Boys' (1984, directed by Mulcahy), which both felt like Mad Max: The Musical. (Somewhat ironically, the 'Wild Boys' video, which was shot on the James Bond stage at Pinewood, cost many, many times more than the first Mad Max movie.)

Queen, meanwhile, used footage from **Metropolis** for their 'Radio Gaga' (1984) video, and Blur remade **A Clockwork Orange** for 'The Universal' (1995).

Listen

The first song ever played on MTV was 'Video Killed The Radio Star' (1980) by The Buggles. The album, **The Age Of Plastic** (1980), was packed with songs containing dystopian themes, with titles like 'I Love You (Miss Robot)' and 'Astroboy (And The Poles On Parade)'. Each track is like a Lego brick for building your own dystopian world.

And if you listen carefully to the lyrics of The Clash's 'London Calling' (1979), you may be surprised to realize that it is a dystopian song as well ('The ice age is coming, the sun's zooming in, Meltdown expected, the wheat is growing thin, A Nuclear error, but I have no fear').

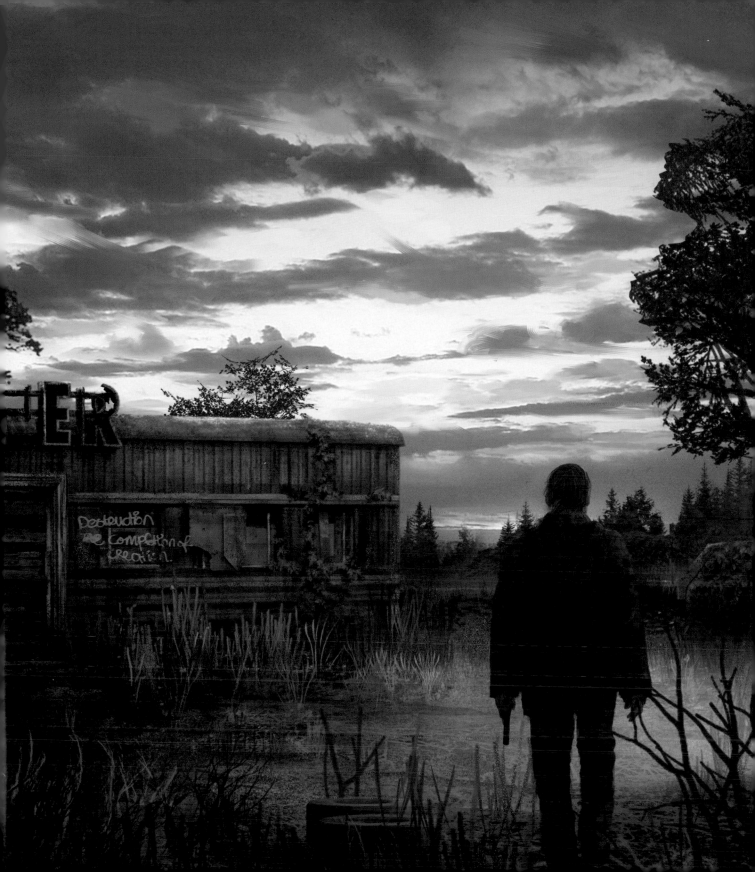

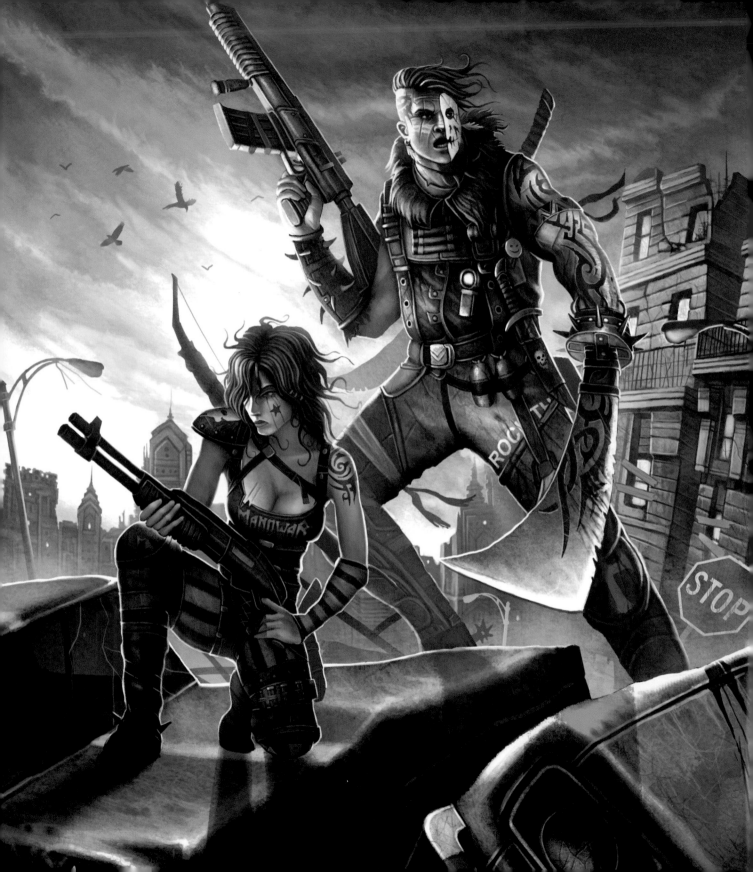

'We all make choices, but in the end our choices make us.'
Ken Levine, Creator of 'BioShock'

The Sound Of Propaganda

Music inspired by **Nineteen Eighty-Four** is a whole subgenre in itself. David Bowie originally wanted to produce a stage musical based on Orwell's book in the early 1970s, but Orwell's wife would not give him the rights. 'For a person who married a socialist with communist leanings, she was the biggest upper-class snob I've ever met in my life,' he complained. He was not deterred though. Instead, the concept became the second side of the **Diamond Dogs** (1974) album, with tracks called 'We Are The Dead', '1984' and 'Big Brother', among several others.

Revolutions Per Minute

Other **Nineteen Eighty-Four**-influenced rock and pop music includes: **1984** (1981), a concept album by Rick Wakeman; **1984** (1981), an instrumental album by Anthony Phillips; '2 + 2 = 5' (2003), a track by Radiohead; **Dystopia** (2003), a concept album based the Two-Minute Hate rallies, by Betty X. Not to mention The Eurythmics' soundtrack album to the 1984 film version, which included songs such as 'Sexcrime (Nineteen Eighty-Four)' and 'Julia' (though they were ultimately dropped from the film).

Muse albums have often featured songs with a dystopian vibe, most obviously **The Resistance** (2009), which features the single 'Uprising,' and **Absolution** (2003) with the song 'Apocalypse Please.'

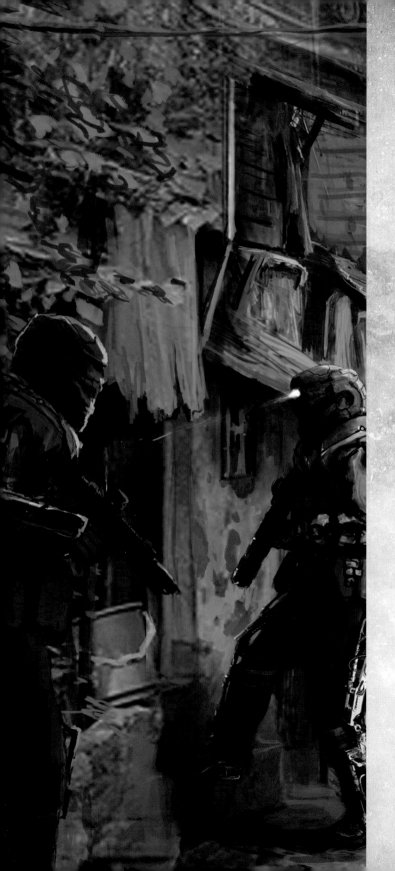

The Concept Is King

Dystopia and concept albums go together like Yes and Roger Dean. Roger Waters made a career out of concept albums about individual spirits being crushed by corrupt powers both during and after his Pink Floyd days (**The Wall**, 1979; **The Final Cut**, 1983; and **Radio K.A.O.S.**, 1987). Gary Numan's **Replicas** (1979) tells the story of a futuristic park in which Machmen kill humans to entertain spectators. Both Styx – with **Kilroy Was Here** (1983, containing the infamous single 'Mr Roboto') – and Frank Zappa – with **Joe's Garage** (1979) – sang about worlds where music was illegal (this was also the theme of Queen's jukebox musical, **We Will Rock You**, 2002).

High Art

Coldplay released **Mylo Xyloto** (2011), which was apparently a love story set in an oppressive, dystopian, urban world, but they had to publish a comic to actually explain what was going on.

There's even dystopian opera. **1984** (2005) saw Orwell's book translated into yet another medium, but it was universally slated by critics as a vanity project by conductor-turned-composer Lorin Maazel. More successful was Poul Ruders' musical interpretation of **The Handmaid's Tale** (2000).

And, of course, there was a rock band actually called Dystopia (1991–2008), whose members were proponents of 'sludge metal' and 'crust punk'.

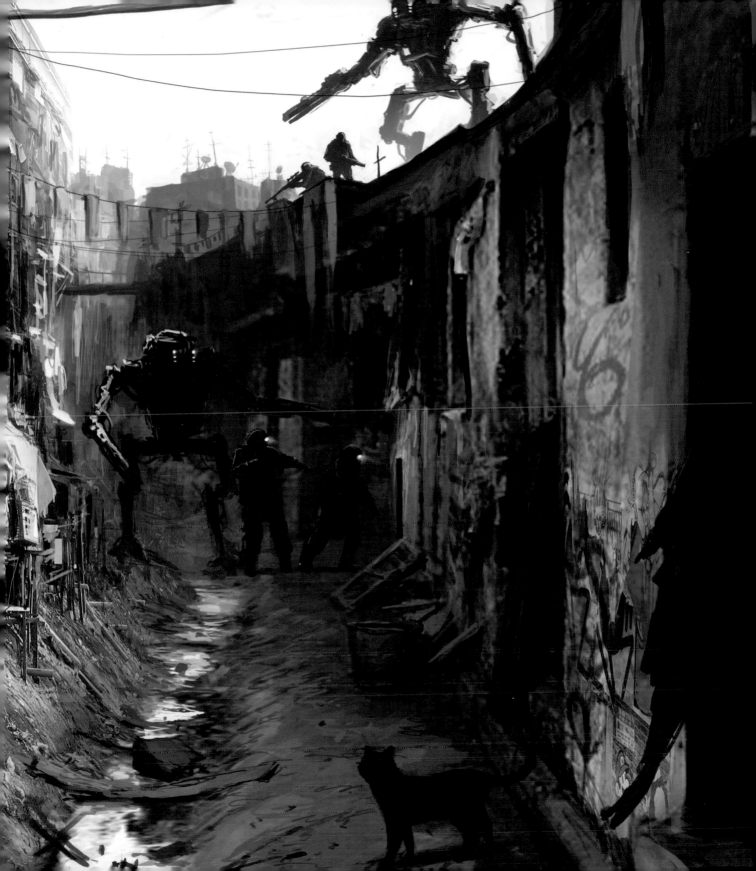

'The machines rose from the ashes of the nuclear fire. Their war to exterminate mankind had raged for decades, but the final battle would not be fought in the future. It would be fought here, in our present. Tonight…'
Opening titles, 'The Terminator'

Time For Some More Commercial

Back on TV, Ridley Scott was in action once again in 1986 for a series of Blade Runner-esque adverts for Barclays with the cunning tagline, 'Do you worry that the more banks become automated, the more you'll become just a number?' In 1989, a memorable ad for McEwan's lager gave Escher's never-ending staircase a dystopian makeover with workers pushing boulders around and around the impossible structure. Phones4U bizarrely decided that the zombie apocalypse was the way to advertise its services in 2011, while Toyota promoted its GT86 in 2012 by showing how shiny it looked driving through a drab dystopian metropolis.

The Digital Dystopia

Early gaming dystopias such as **Shadowrun** (1993) and **Syndicate** (1993) were set in fairly generic future cities, though Zelda had fun with an evil alternative future Hyrule in **A Link To The Past** (1991) and **Ocarina Of Time** (1998).

But with the new millennium, games have created some memorable dystopias of their own. **BioShock** (2007) and **BioShock 2**'s (2011) dual dystopia – the underwater city of Rapture, and Columbia, the city in the clouds – features some strikingly original designs and creepy concepts. Columbia is like a weird steampunk carnival run by sociopaths. Creator Ken Levine is a self-confessed dystopia fan, and it shows.

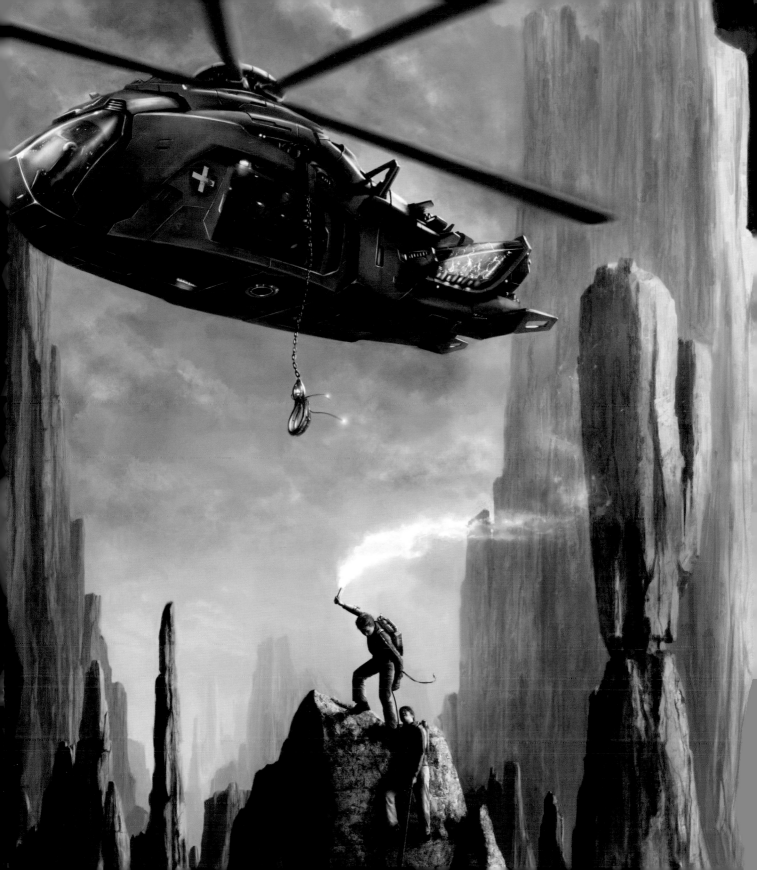

Not Half Scary

Anyone who has ever played **Half Life 2** (2004) will shiver at the phrase 'Welcome to City 17'. That bland invitation, given by the game's Big Brother, Dr Breen (he's on every screen!), introduces you to an urban sprawl that's like **Escape From New York** meets Soviet-era Russia. You'll lose count of the number of times you get a rifle butt to the chin.

Papers, Please (2013) has an interesting twist, as you play a border guard in a dystopian country. With deliberately drab graphics, it is an oddly addictive and immersive experience.

And if you want to actually build your own dystopia, there's always **SimCity Societies** (2007).

Tokyo Storm Warning

And if you prefer your dystopias anime-style, you can do no better than to start with the seminal **Akira** (1988), set in a post-nuclear-war Tokyo that's been rebuilt by the architects of Mega-City One. **Fist Of The North Star** (1986) is also post-nuclear-war, while **Ghost In The Shell** (1995) is set in a world where the machines look likely to take over any minute by stealth.

Or you might want to catch the live action film **Battle Royale** (2000) just so you can be one of those movie snobs who can say, '**Hunger Games**? That's just a rip-off of a much better Japanese film.'

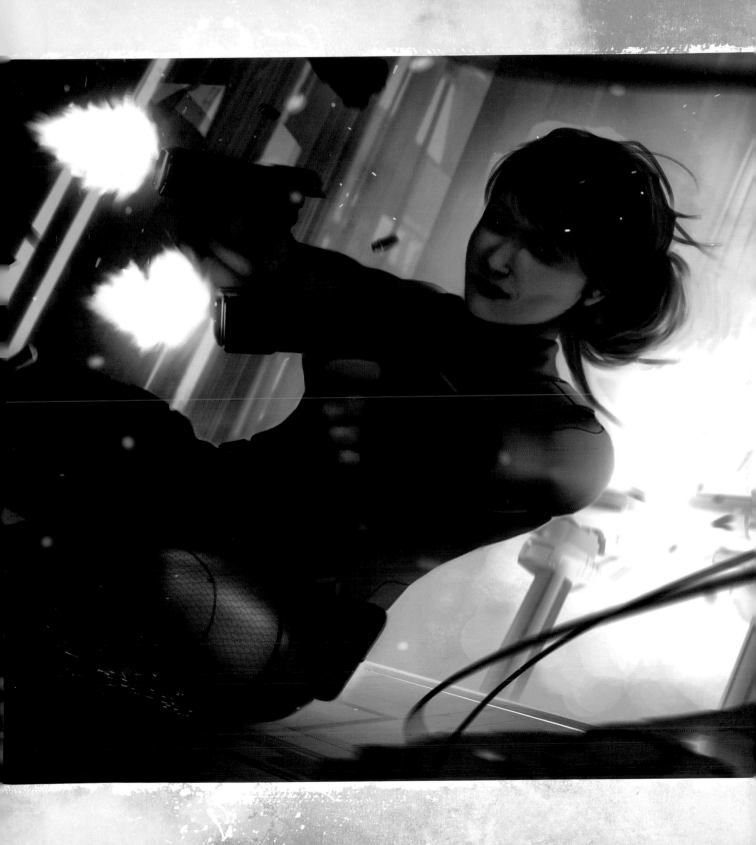

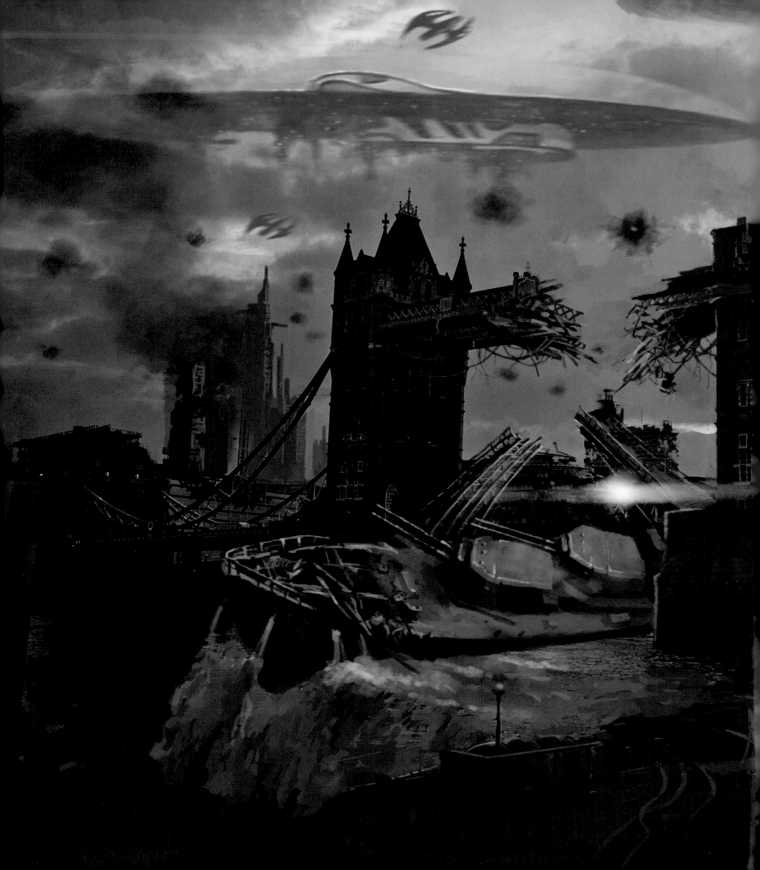

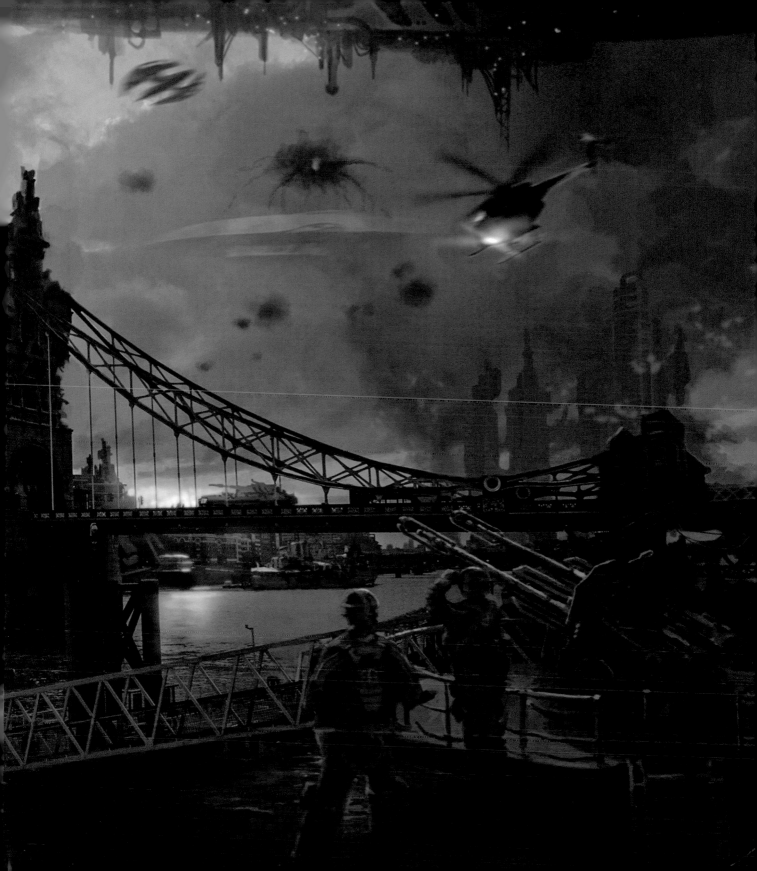

Something To Keep You Going

Dystopian Fashion On Pinterest:

www.pinterest.com/nikavega/dystopian-fashion

If you fancy doing some dystopian cosplay, there's plenty
of inspiration here.

Utopia And Dystopia:

www.utopiaanddystopia.com

An accessible introduction to the concepts; not too highbrow.

The Walking Dead Forums: www.walkingdeadforums.com

Friendly, comprehensive coverage of the TV hit.

Hunger Games Trilogy Fansite:

www.hungergamestrilogy.net

Keep up to date with all the news from the franchise.

Deviant Art:

www.deviantart.com

It's where all the coolest artists hang out. Type 'dystopia'
in the search field, browse and be amazed.

Dystopia Game:

www.dystopia-game.com

If you already own a Source-powered Valve game, you
can download this cyberpunk-themed total conversion of
Half Life 2 for free.

Dystopia Comic:

dystopiacomic.smackjeeves.com

Free-to-read webcomic.

Bladezone: www.bladezone.com

A ramshackle but incredibly comprehensive **Blade Runner** fansite.

Duran Duran: Arena (An Absurd Notion):

www.youtube.com/watch?v=m_LjFu5IitY

Watch on YouTube the making of possibly the only dystopian live pop concert video ever made.

William Gibson:

www.williamgibsonbooks.com

Official site of the necromancer author.

Roger Dean: www.rogerdean.com

Packed with pics and videos, the official site of the Yes album cover artist.

Aaron Beck blog:

skul4aface.blogspot.co.uk/2013/09/elysium-artwork.html

Packed with concept designs from films such as *Elysium*.

Ben Mauro blog: benmauro.blogspot.co.uk

More gorgeous cyberpunk and dystopian concept art.

Alex Andreev: www.alexandreev.com

A gallery of stunning works from the Russian artist.

10 Songs Inspired by Nineteen Eighty-Four:

romnovelstonotes.wordpress.com/2013/03/19/10-songs-inspired-by-george-orwells-1984

Bowie, Muse and more. And you can listen to each one.

John Wentz site: www.wentzart.net

This is what gallery-style post-apocalyptic art looks like.

The Boy With Nails For Eyes:

basement-garden.co.uk

The comic and other art by Shaun Gardiner can be found here.

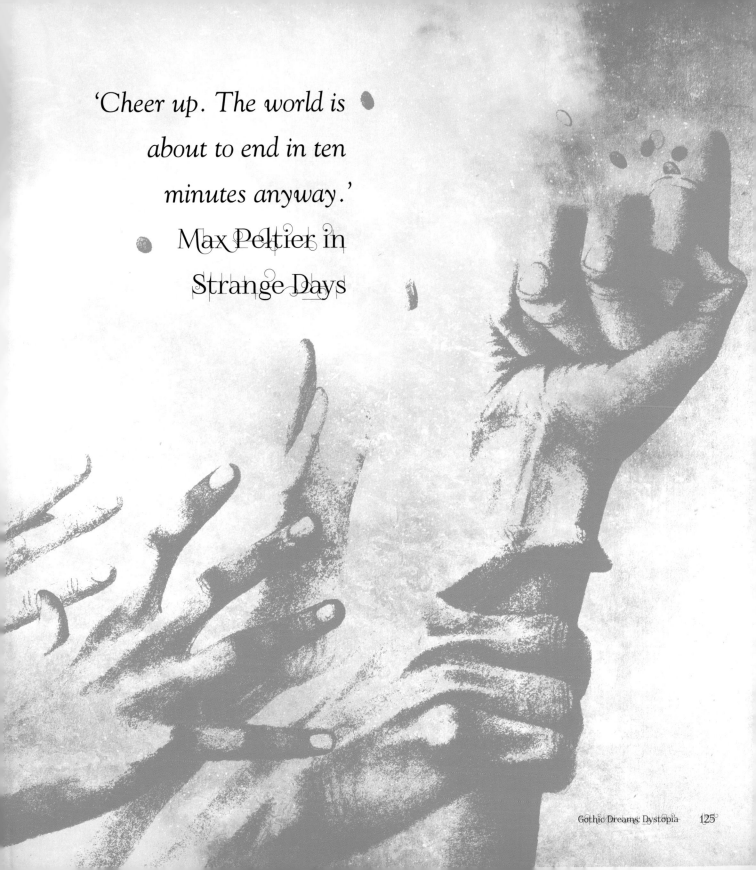

'Cheer up. The world is
about to end in ten
minutes anyway.'
Max Peltier in
Strange Days

Acknowledgements

Biographies

Dave Golder (Author)

Dave Golder is a former editor of **SFX** magazine (which he helped to launch), SFX.co.uk and **Comic Heroes** magazine, but he first began writing professionally about science fiction with a regular feature in **Your Sinclair** called The Killer Kolumn From Outer Space. He has also written for various gaming magazines despite only ever having finished two games completely, and one of those was **Kung Fu Panda**. He now works freelance and is pretending to write a novel.

Pat Mills (Foreword)

Pat Mills is a comics editor and writer who has played a vital role in British comics since the 1970s. He is perhaps best known for his dystopian comics, such as **Marshal Law** and **Requiem Vampire Knight**, for founding **2000 AD** and for playing a crucial role in the creation of Judge Dredd.

Links

Find out more about the fantastic artists, authors and sources of the steampunk quotes in this book:

www.flametree451.com

Picture Credits

The Artists

Special thanks to all the artists who have contributed artwork to this book:

Nivanh Chanthara (duster132.carbonmade.com) 4; **Aaron Wilkerson** 7, 110; **Michael Wang** 9; **David Velazquez** and **Francesc Camos Abril** 10, 67; **Filip Dudek** 12, 114–15; **Brenoch Adams** (brenoch.com) 15, 48, 72; **Aleksey Andreev** 16; **Francisco Badilla** 19; **Simon Fetscher** (simonfetscher. tumblr.com) 21; **Clint Langley** A.B.C. WARRIORS™ REBELLION®A/S, ©REBELLION®A/S, All rights reserved 22, 54 AMERICAN REAPER™ © Repeat Offenders Ltd 68, 90, 104; **Shaun Gardiner** (basement-garden.co.uk) 25,122–24; **Kim Solomon** 27; **Ross Damien Jordan** (inspired by Jonathan Gales's 'Megalomania') 28; **Jesse Seiterä** 32, 59; **Farrukh Safarzade** 34; **Cédric Peyravernay** (cedricpeyravernay.tumblr.com) 38; **Ashley Walters** (ashleywalters.net) 42; **Raido Kaasik** 45; *Cyber Cop* by **Markus Vogt** (markusvogt.eu) 51; Photographer: **Alex Zatsepin**, Model: **Elisanth**, Make-up artist: **Funfmarz** 52; **Alexander Ovchinnikov** 53; **Christian 'Tigaer' Hecker** 56, 82; **Tony Andreas Rudolph** (zulusplitter.de) 60; **Luke Denby** 63; **Alexander Chelyshev** (sanchiko.deviantart.com) 64; **Adam Varga** 74; **Neil MacCormack** 77; **Raphael Lacoste** 78; **Lorenz Hideyoshi Ruwwe** 81, 41; **Sina Pakzad Kasra** (sinakasra.blogspot.com) 85; **Paul Alexandrescu** (Lexpaul.com) 89; **Blake Rottinger** (BlakeRottingerArt.com) 92; **Olivier Ledroit** in Requiem Vampire Knight © Mills/Ledroit/Nickel 2000, 2003, 2015 All rights reserved 94, 95, 102; **Viktor Koroedov** 101; **Erik Schumacher** and **Gaétan Weltzer** 106; *Alone* © **François Baranger** 109; **Dusan Markovic** 112; **Fahrija Velic** 117; **Lothar Zhou** (lotharzhouart.co.uk) 120; **Zoltan Toth** 127; **Shinomiya Yoshitoshi** 128.

Other Picture Sources

Courtesy of/© **Photoshot** and the following collections: 37, 97, 98; **LFI** 31, 41, 86; **Collection Christophel** 30, 47, 71. Courtesy of/© **Shutterstock** and the following for recurring decorations: Karol Kozlowski; Mara008; Stokkete (and front cover); rarach; Elena Schweitzer; vectorbomb; andrea crisante; David Orcea; Eric Isselee; MishelVerini.

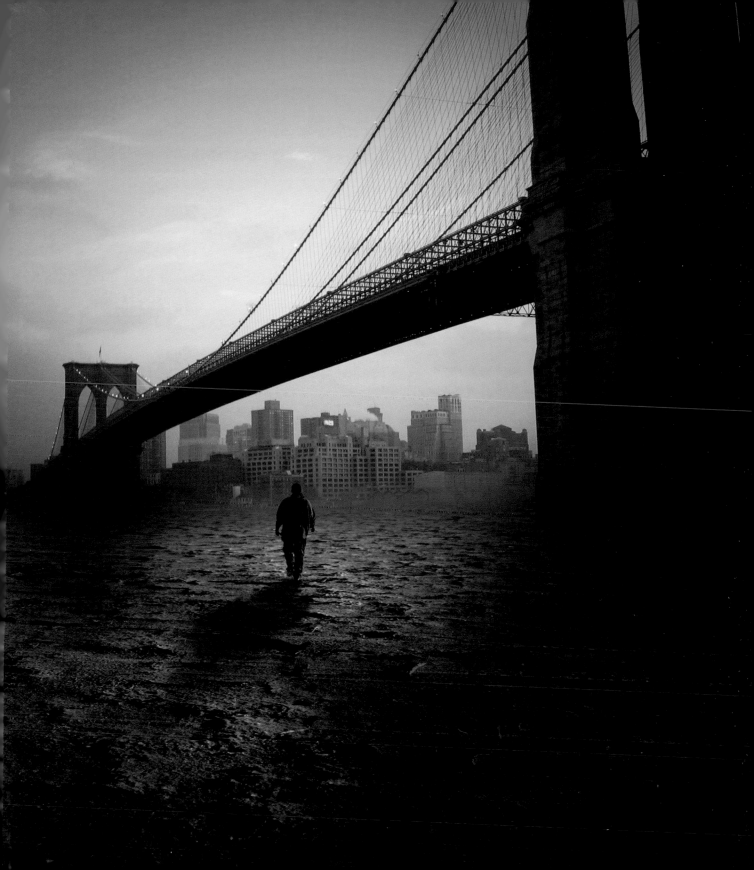

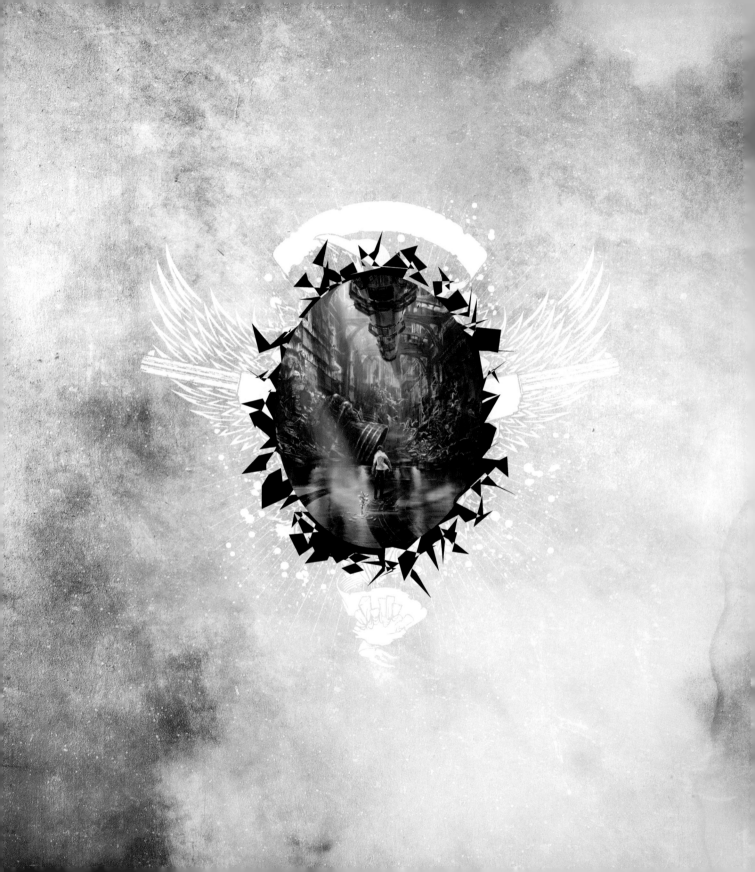